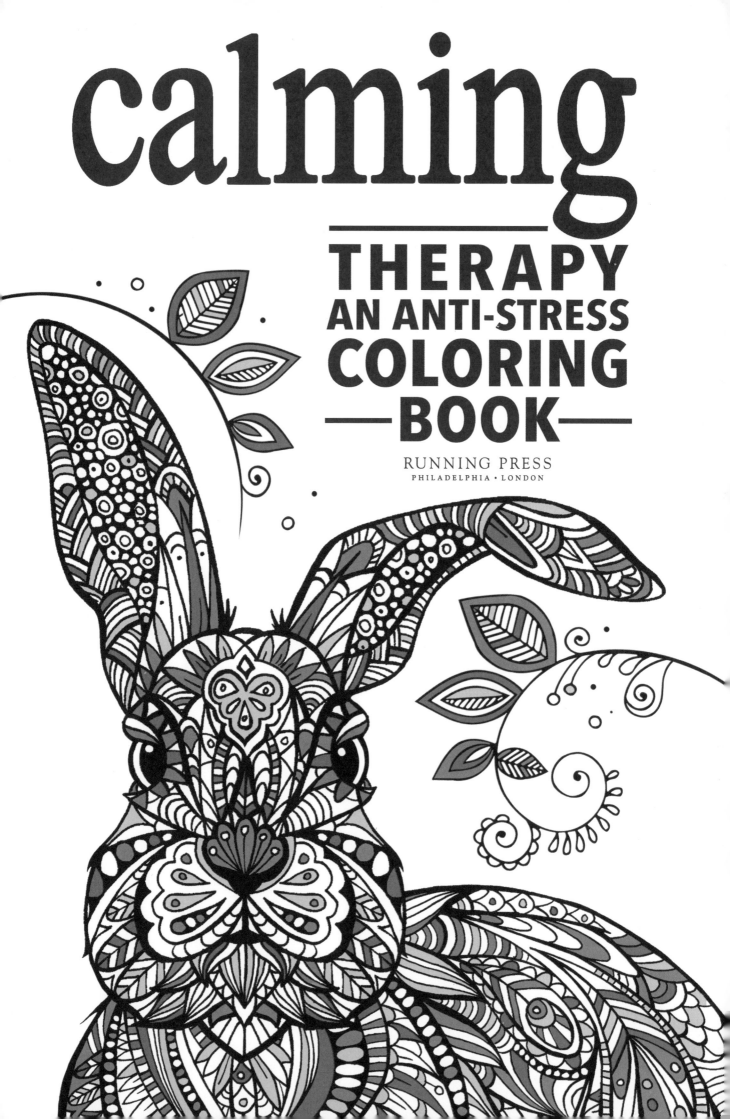

calming

THERAPY
AN ANTI-STRESS
COLORING
BOOK

RUNNING PRESS
PHILADELPHIA • LONDON

Illustrated by Hannah Davies, Richard Merritt and Cindy Wilde

Edited by Hannah Cohen
Cover design by John Bigwood
Designed by Jack Clucas

With additional material adapted from www.shutterstock.com
One Image by Sam Loman.

First published in the United States in 2015 by Running Press Book Publishers
A Member of the Perseus Books Group

Printed in China

Books published by Running Press are available at special discounts for bulk purchases in the United States by corporations, institutions, and other organizations. For more information, please contact the Special Markets Department at the Perseus Books Group, 2300 Chestnut Street, Suite 200, Philadelphia, PA 19103, or call (800) 810-4145, ext. 5000, or e-mail special.markets@perseusbooks.com.

ISBN 978-0-7624-5960-5
Library of Congress Control Number: 2015940925

9 8 7 6 5 4 3 2 1
Digit on the right indicates the number of this printing

Running Press Book Publishers
2300 Chestnut Street
Philadelphia, PA 19103-4371

Visit us on the web!
www.runningpress.com

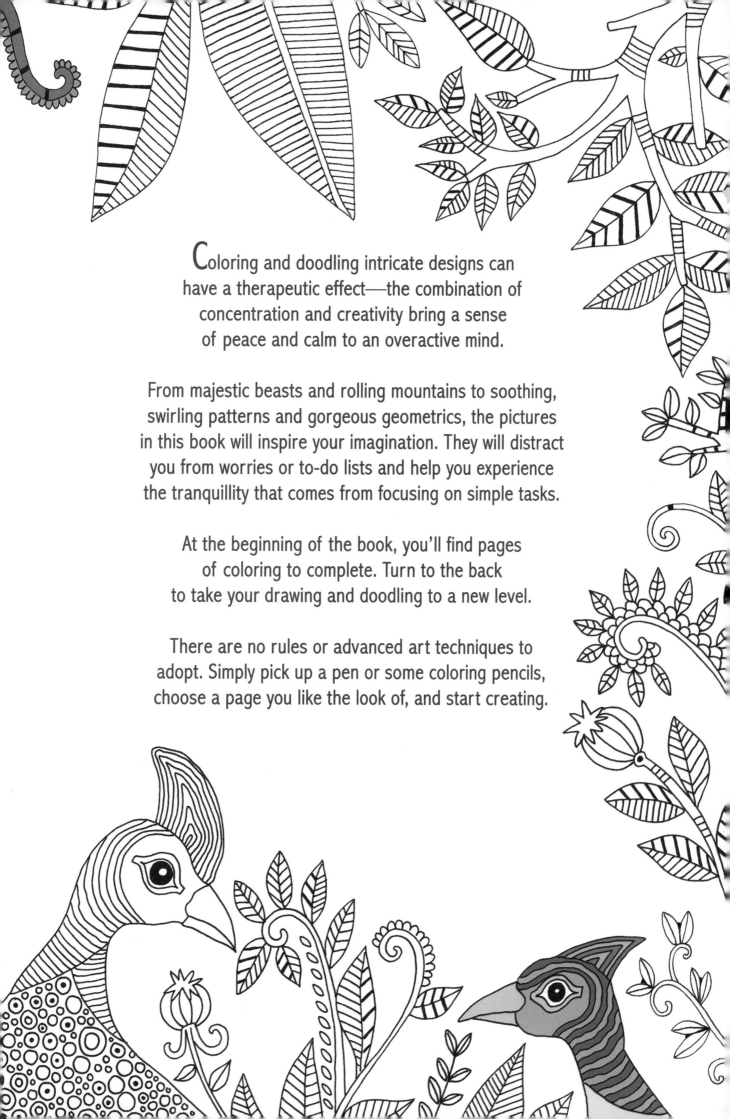

Coloring and doodling intricate designs can have a therapeutic effect—the combination of concentration and creativity bring a sense of peace and calm to an overactive mind.

From majestic beasts and rolling mountains to soothing, swirling patterns and gorgeous geometrics, the pictures in this book will inspire your imagination. They will distract you from worries or to-do lists and help you experience the tranquillity that comes from focusing on simple tasks.

At the beginning of the book, you'll find pages of coloring to complete. Turn to the back to take your drawing and doodling to a new level.

There are no rules or advanced art techniques to adopt. Simply pick up a pen or some coloring pencils, choose a page you like the look of, and start creating.

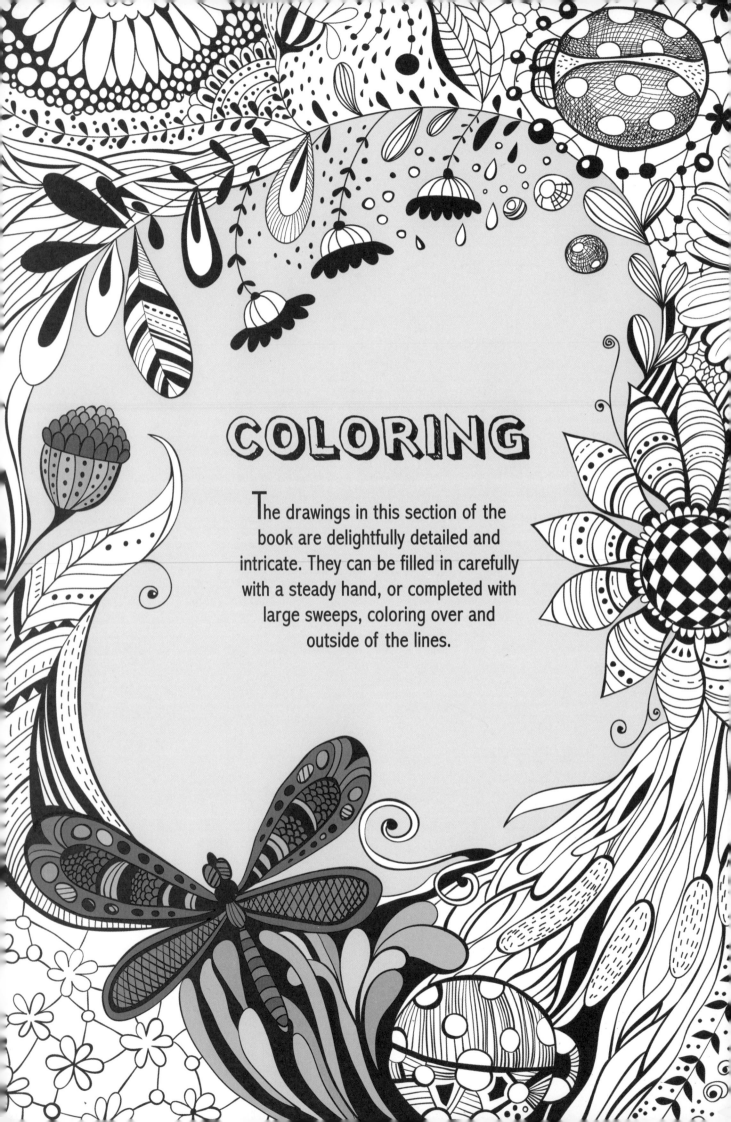

COLORING

The drawings in this section of the book are delightfully detailed and intricate. They can be filled in carefully with a steady hand, or completed with large sweeps, coloring over and outside of the lines.

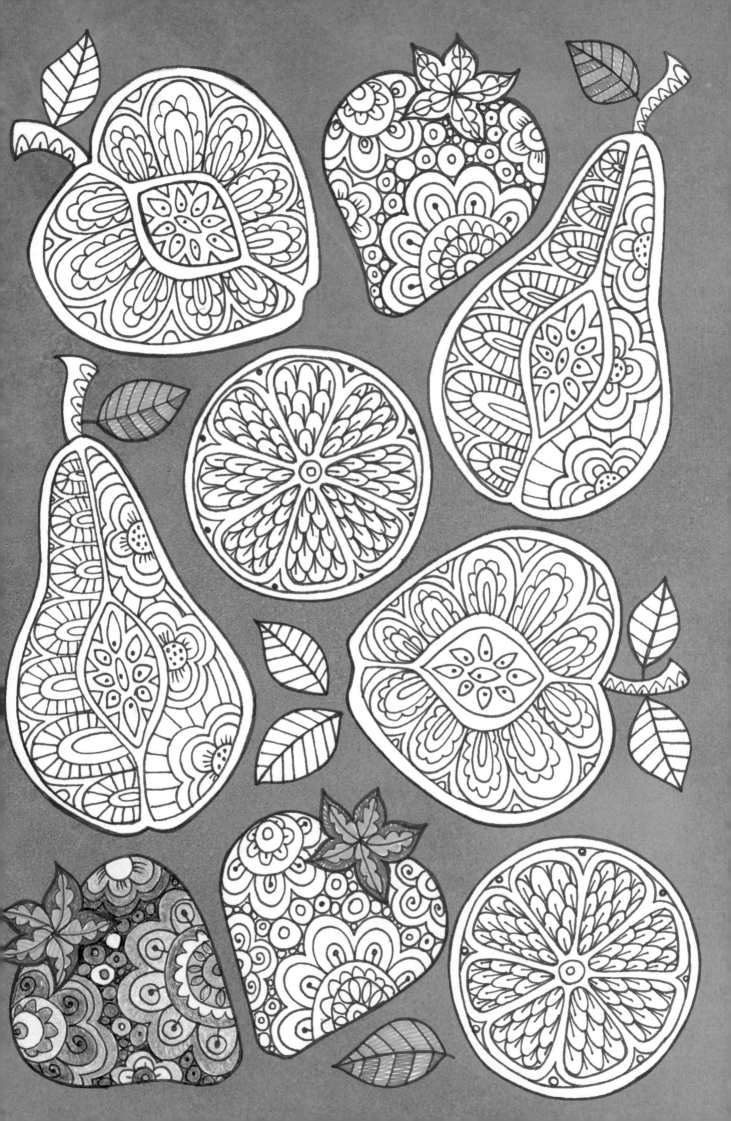

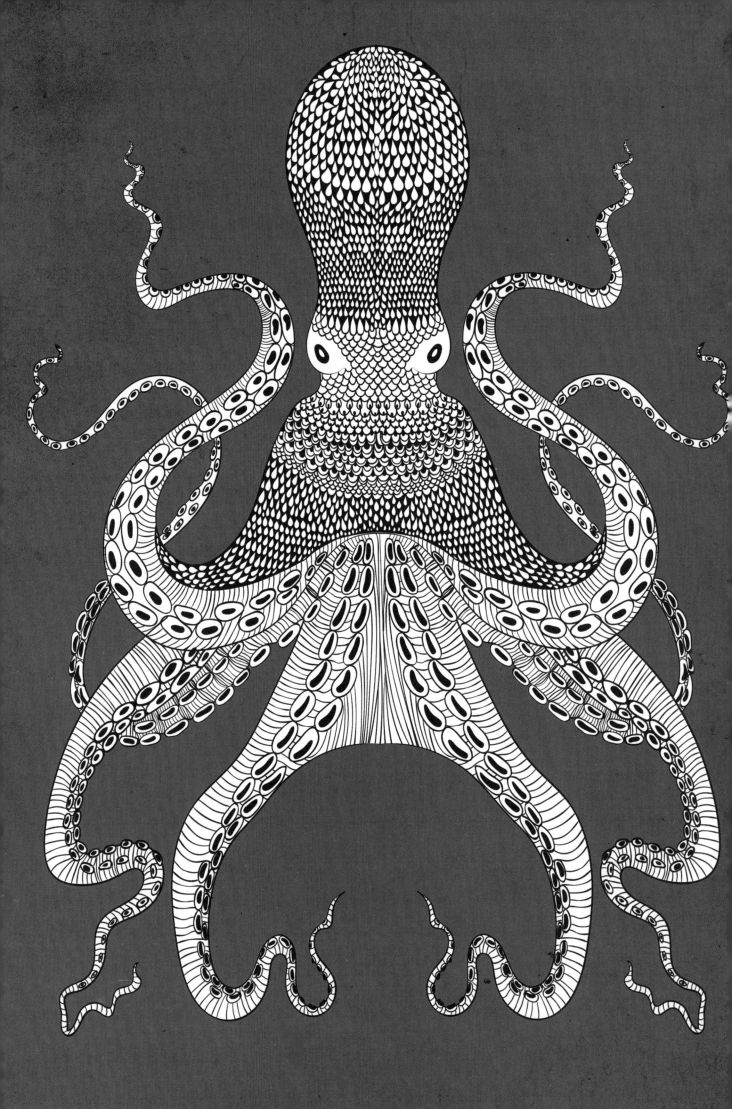

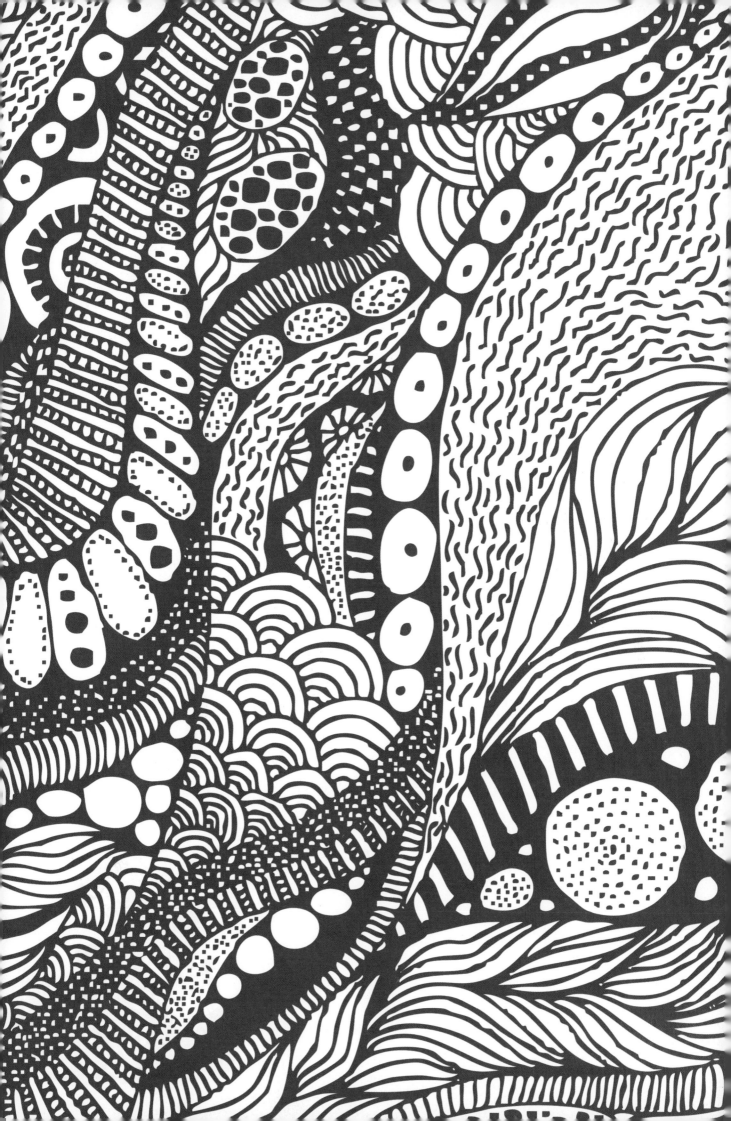

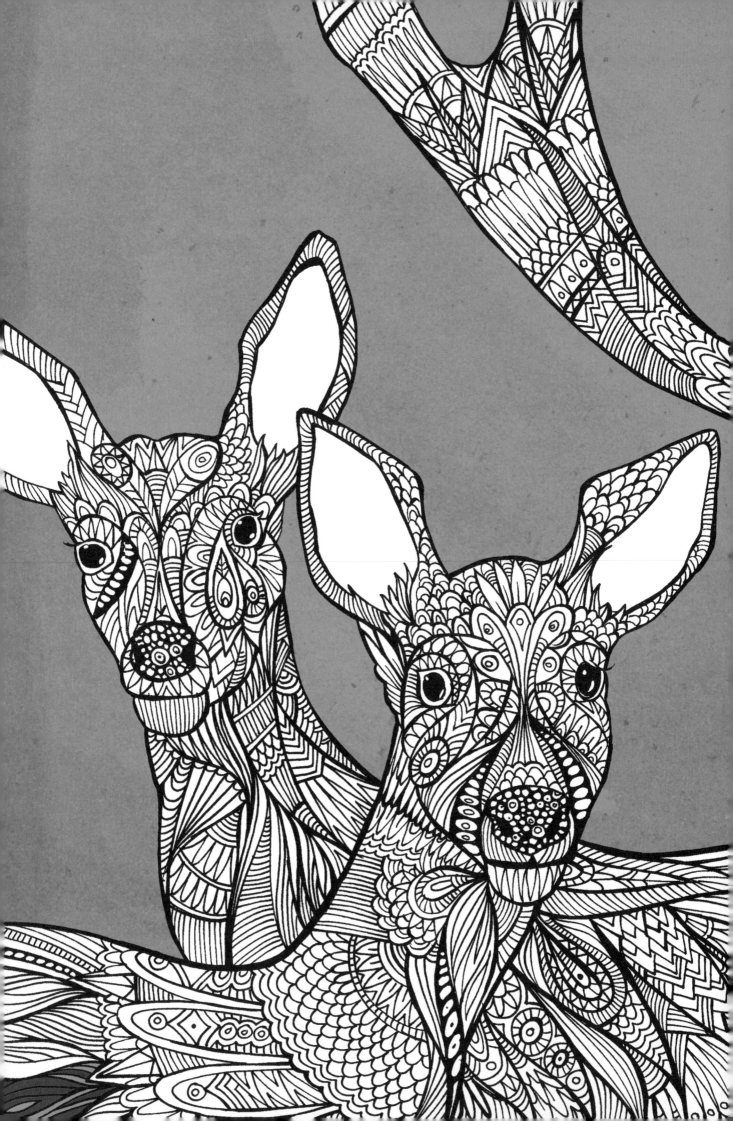

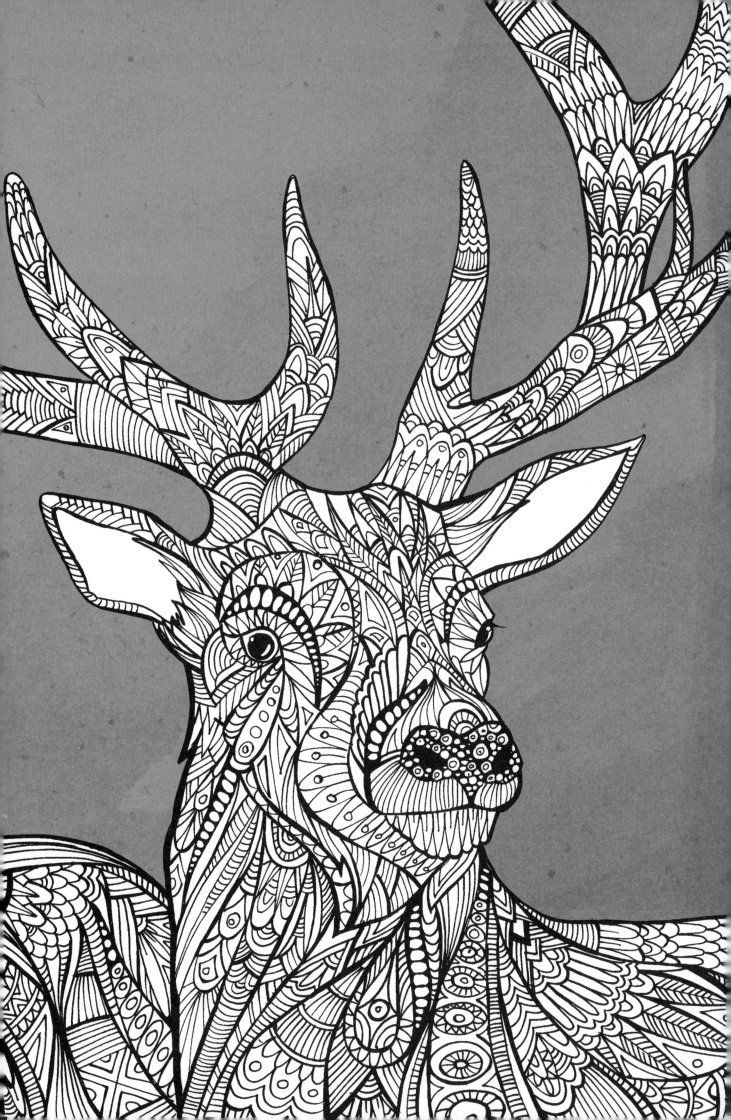

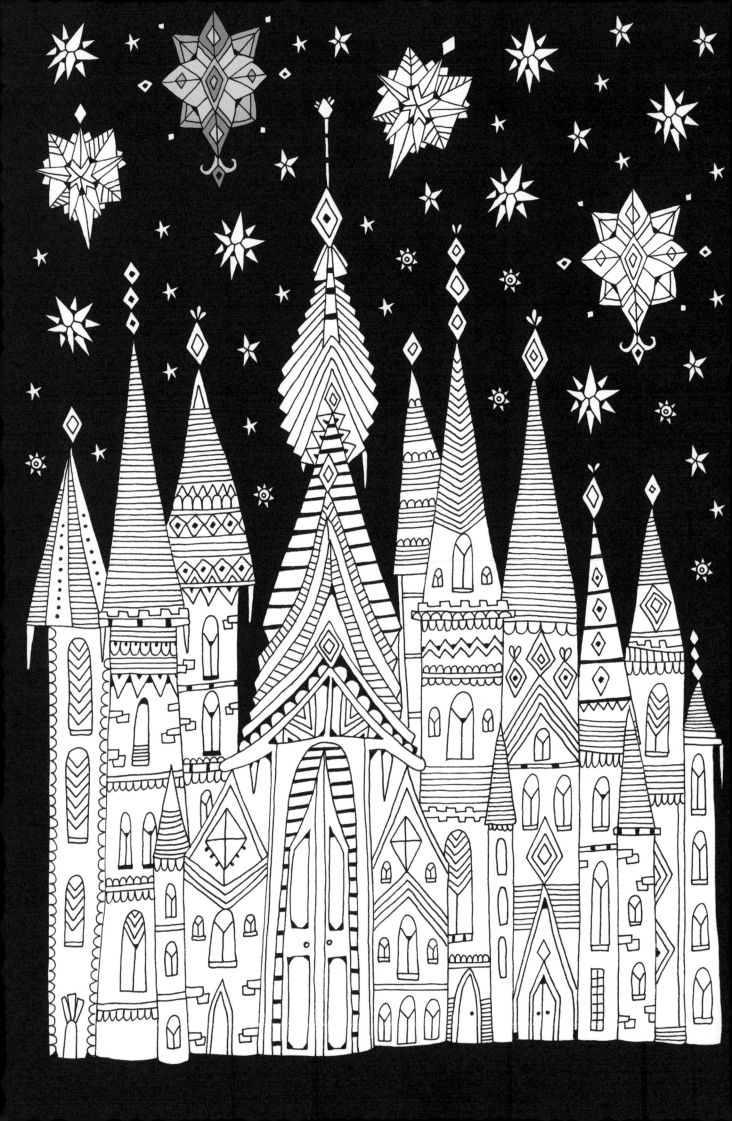

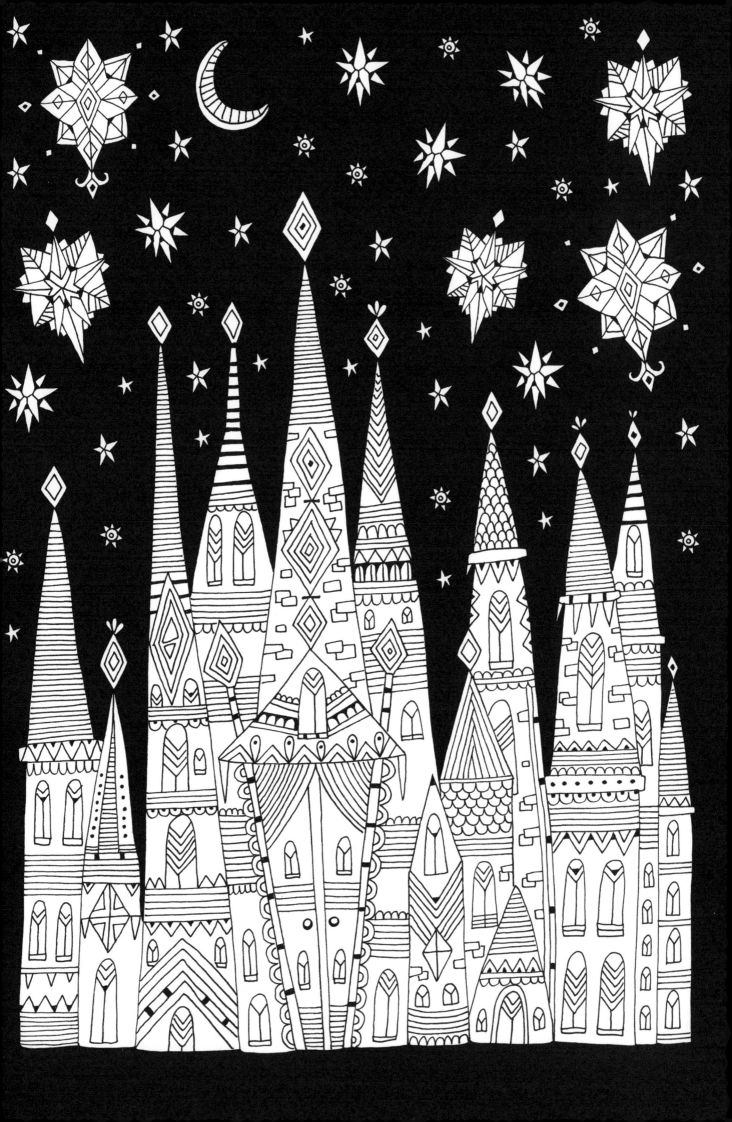

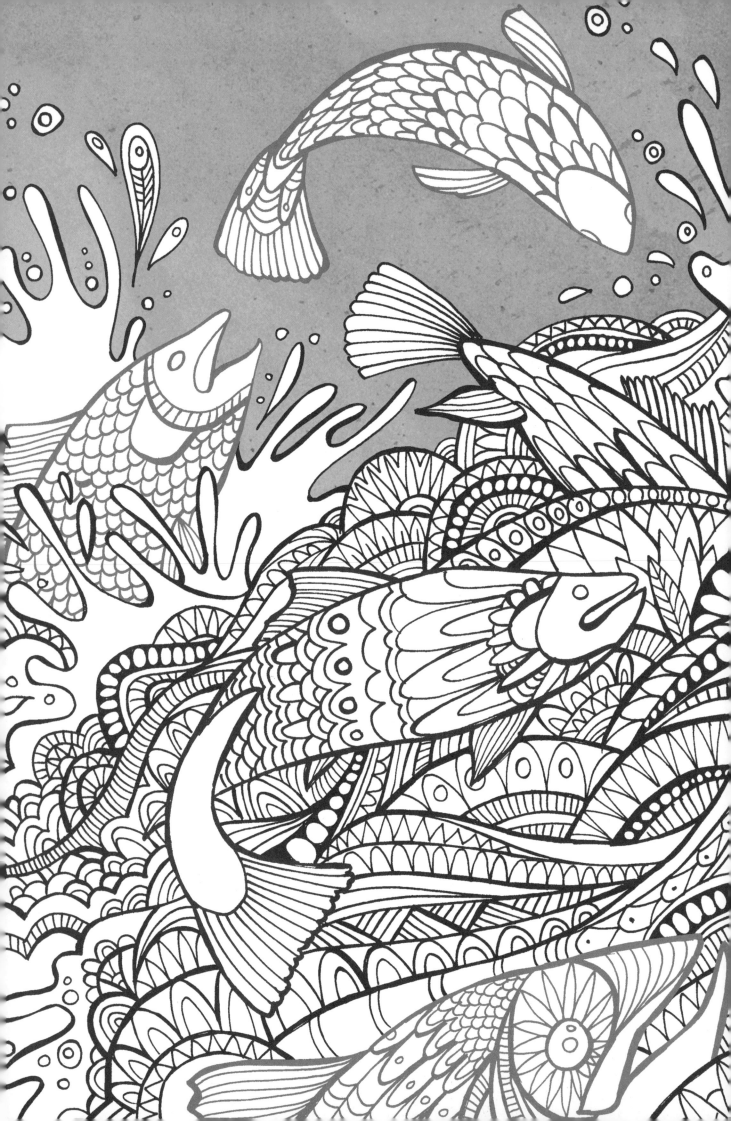

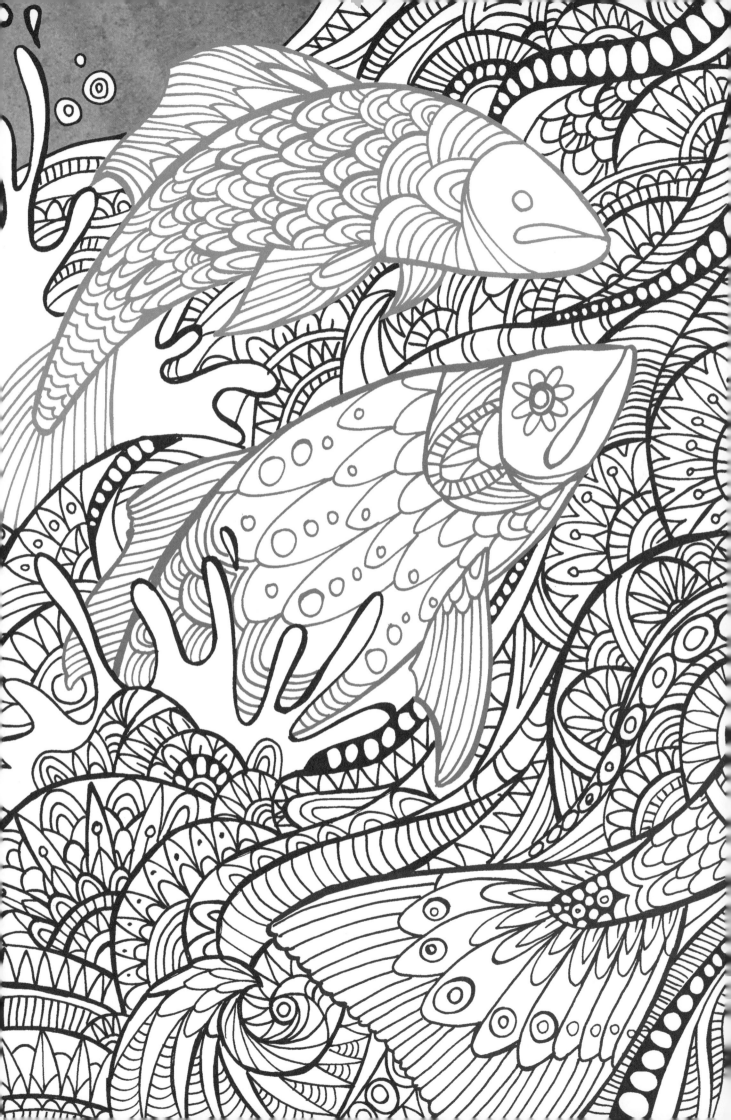

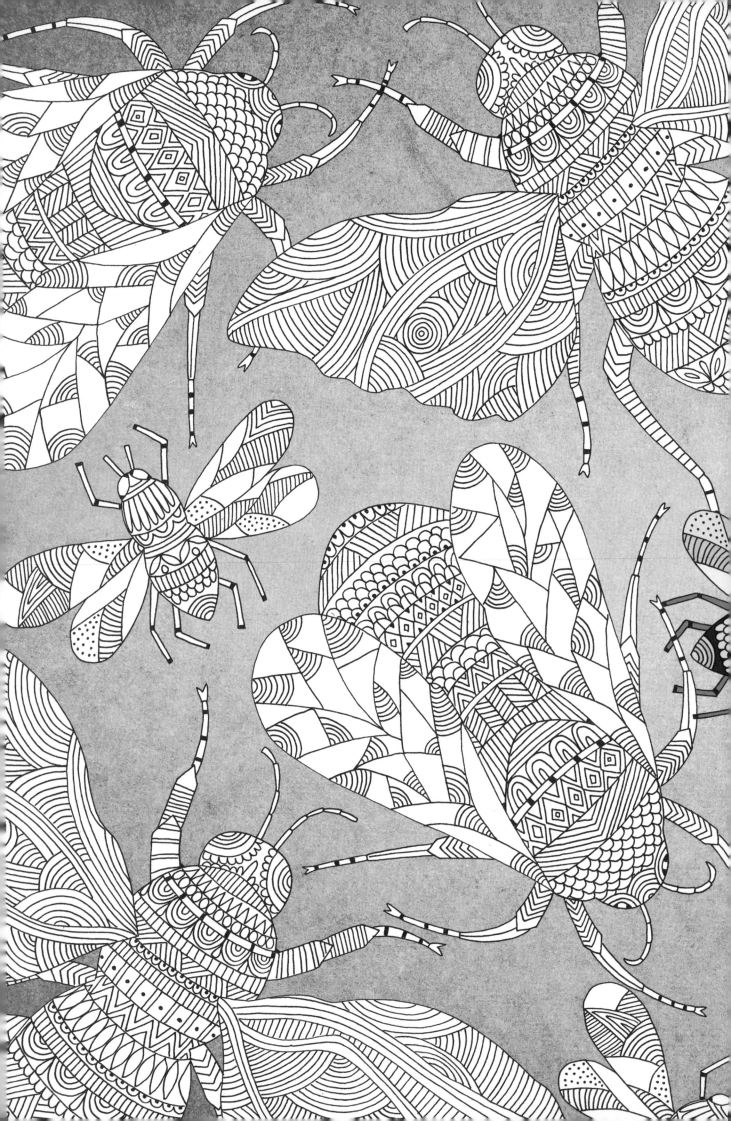

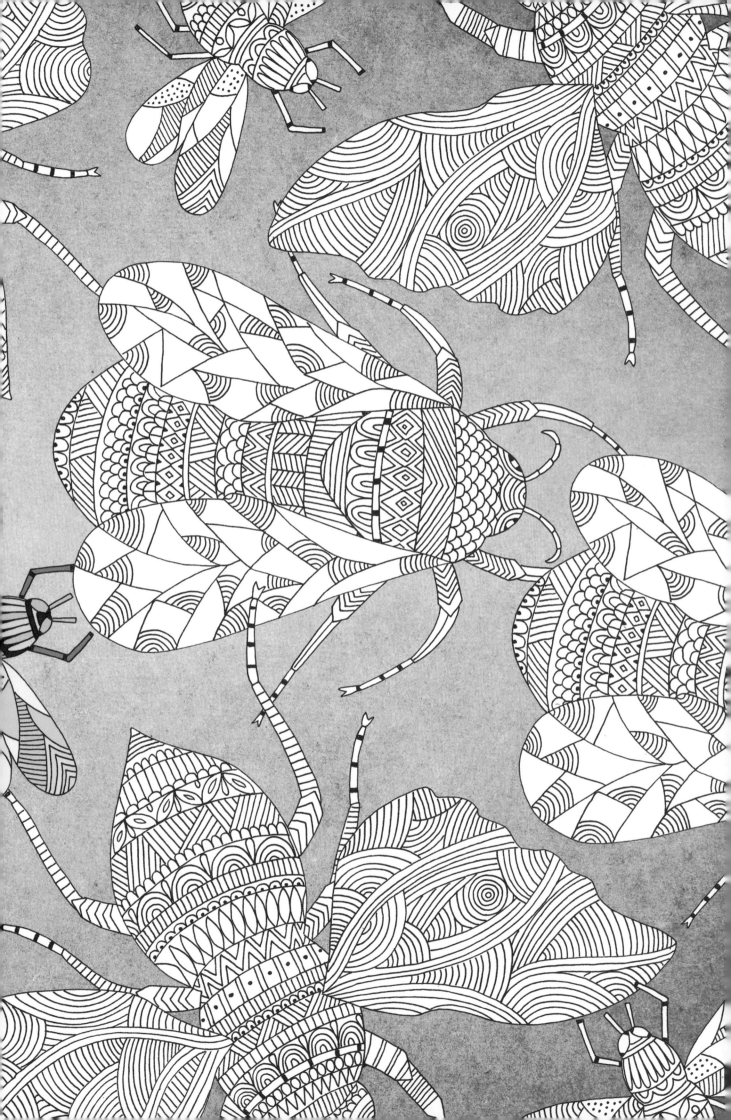

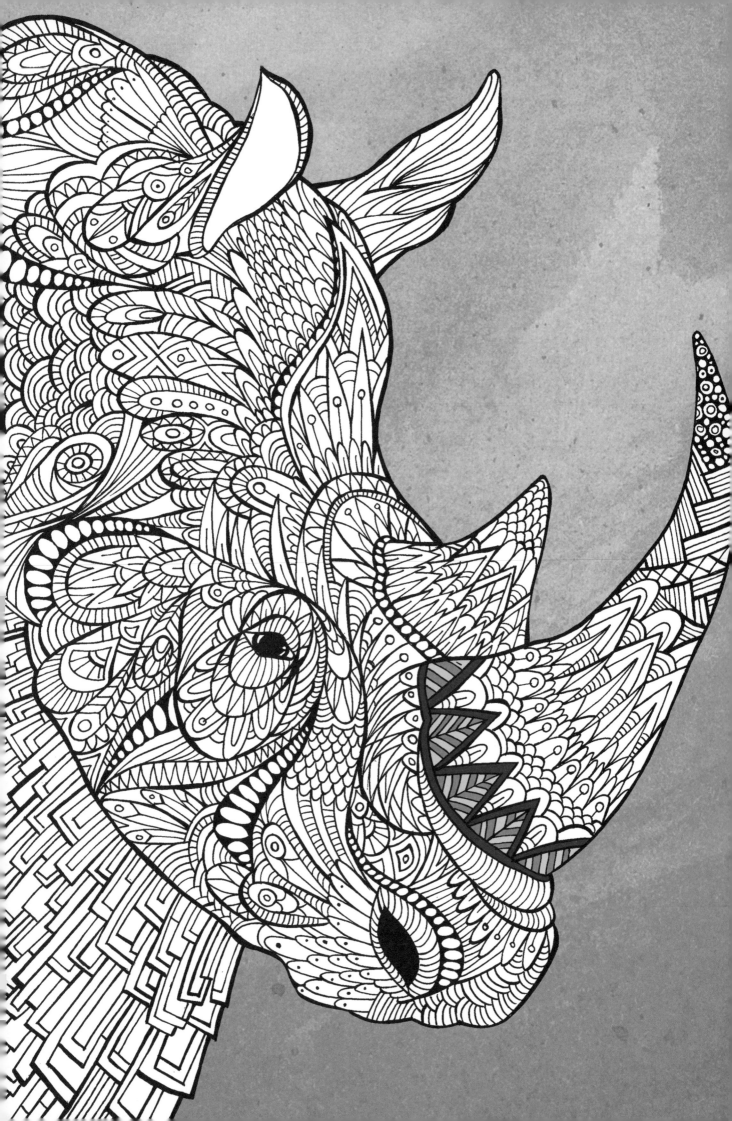

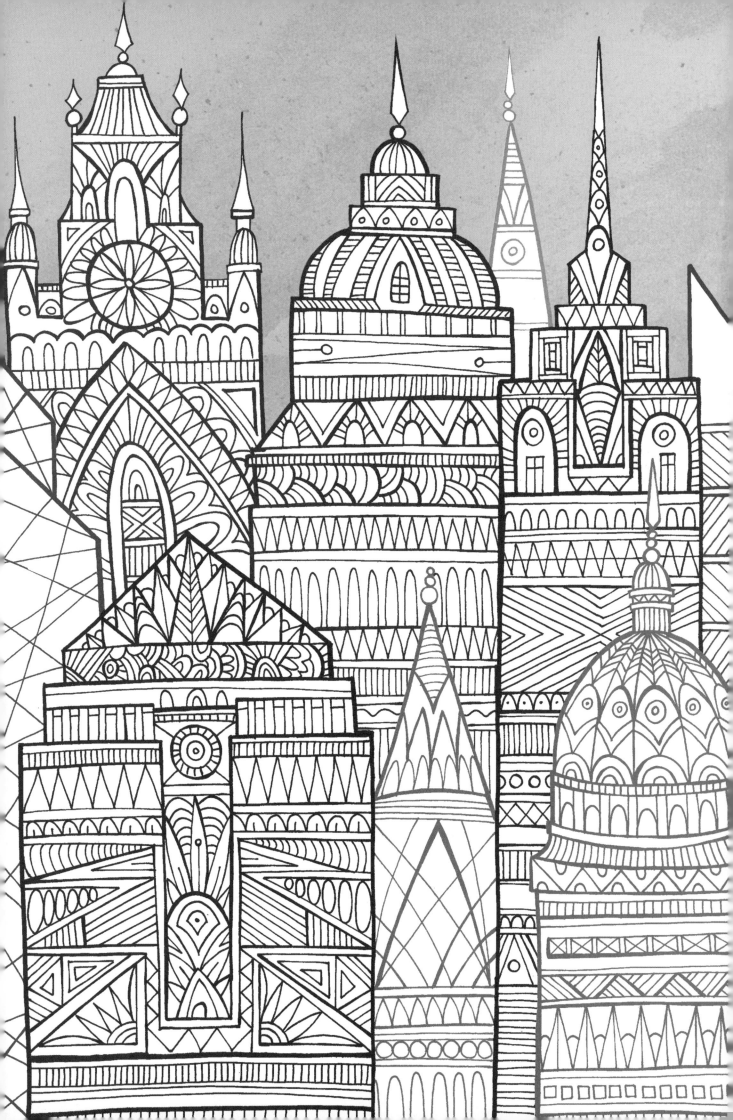

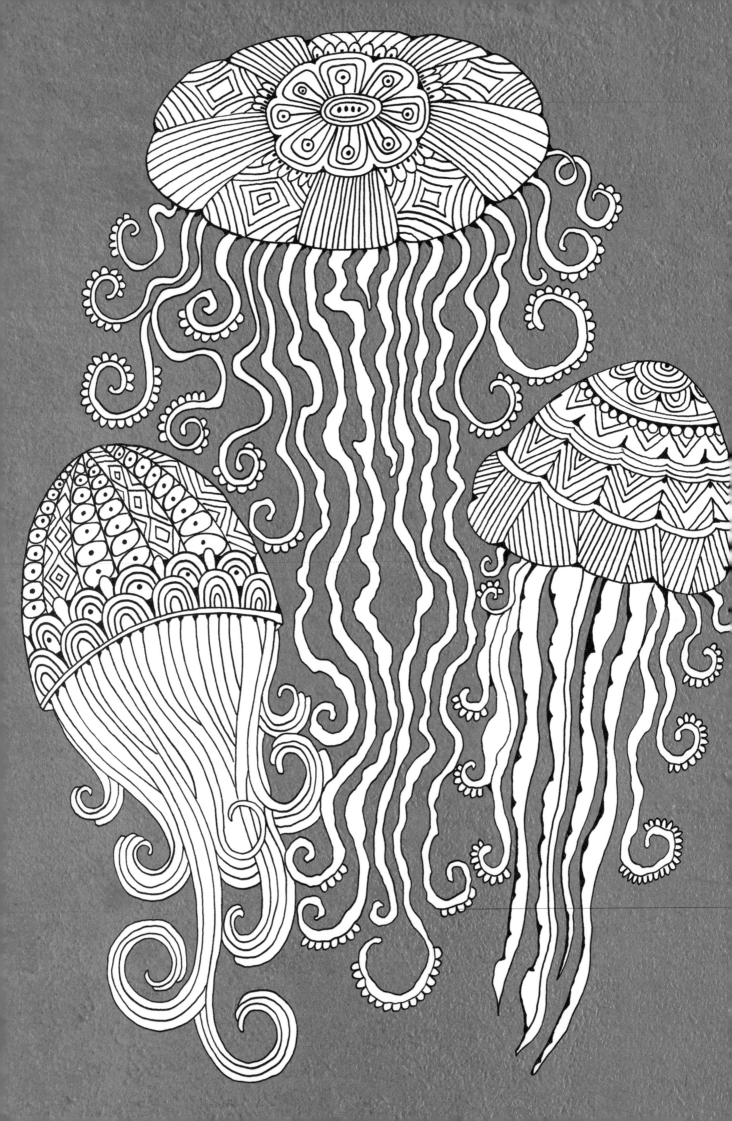

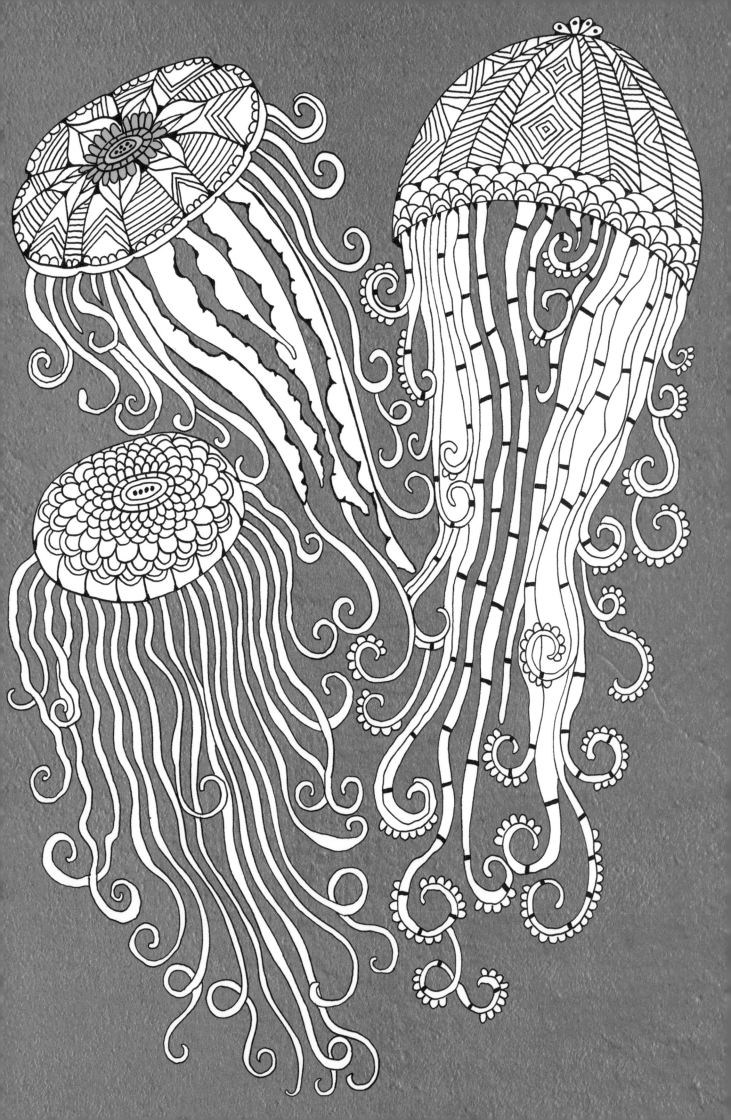

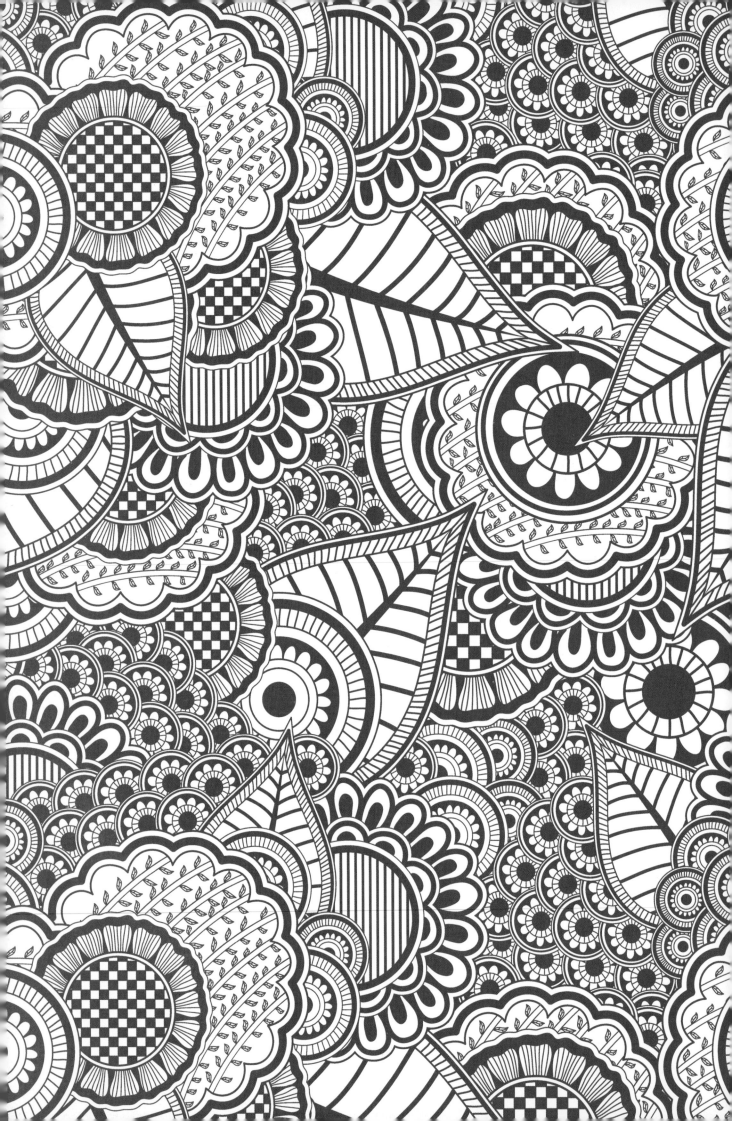

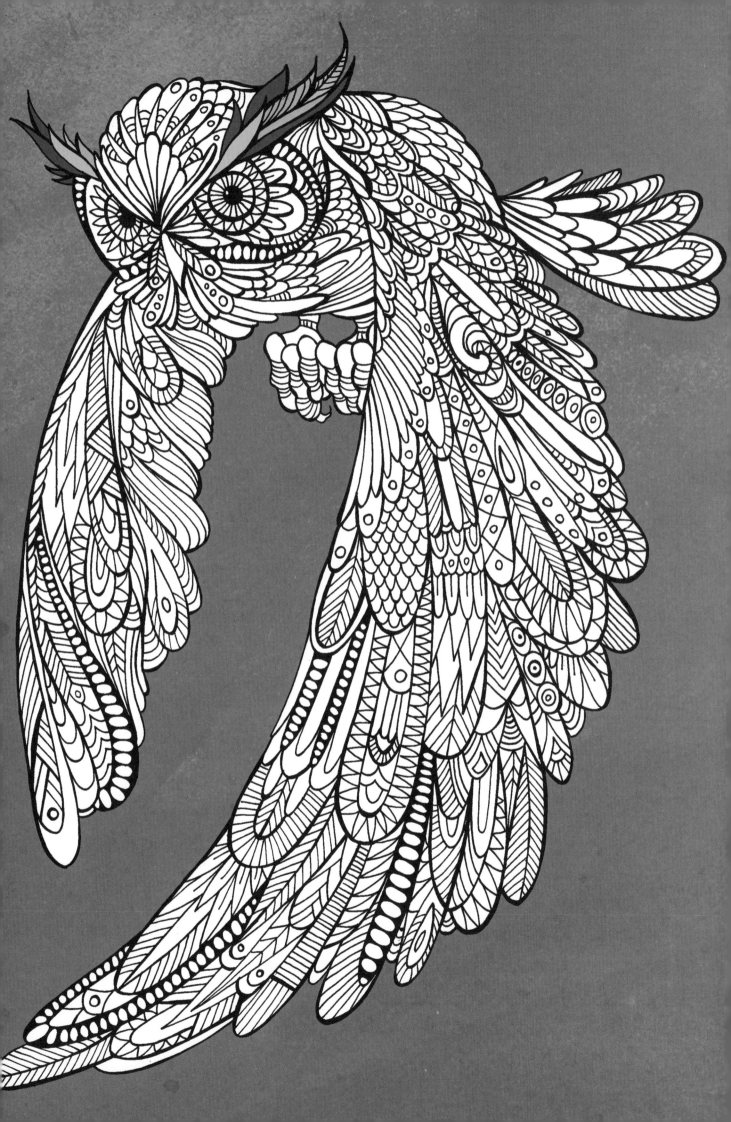

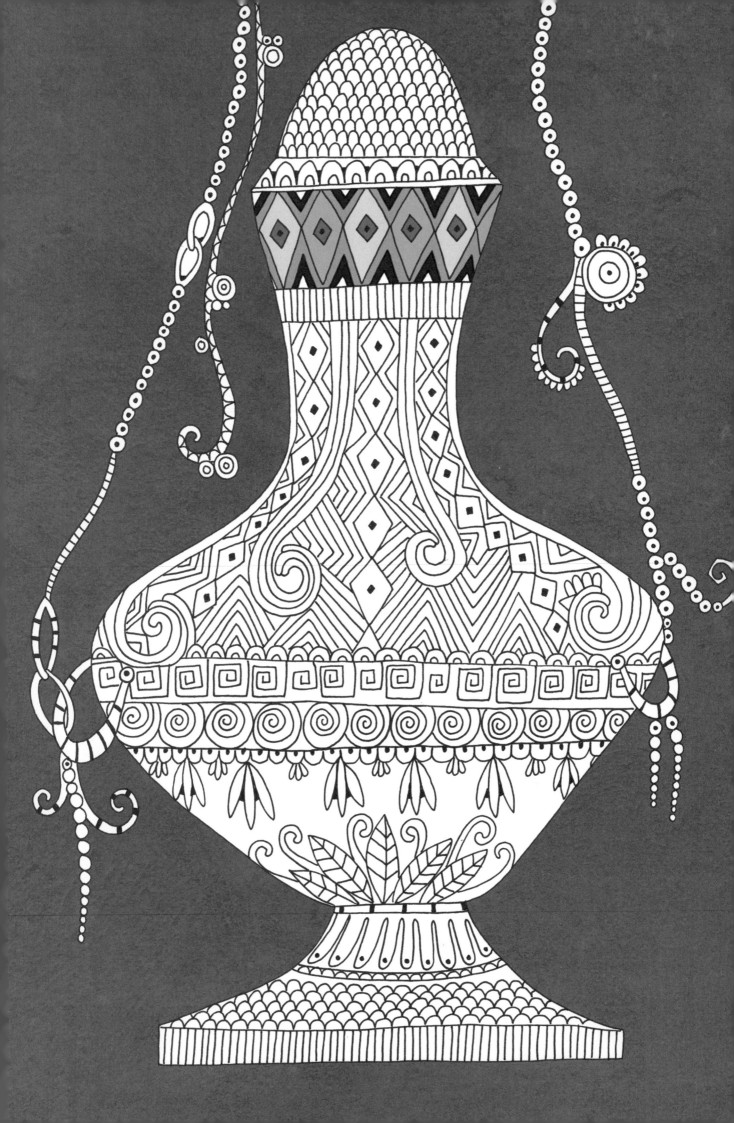

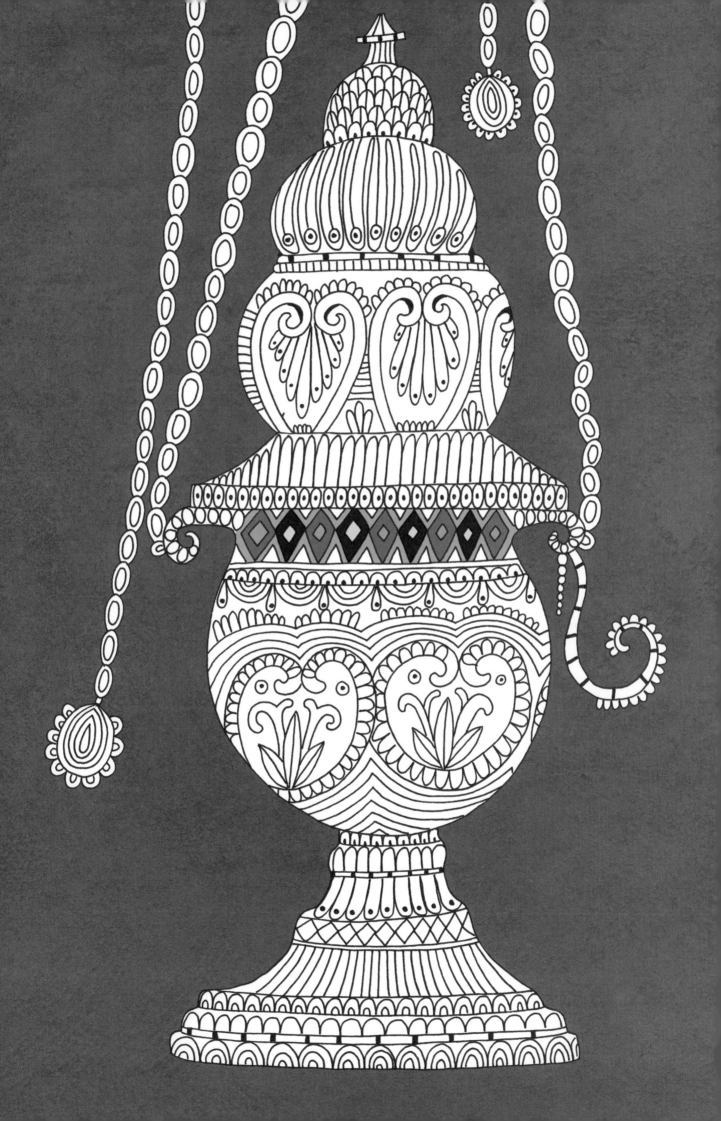

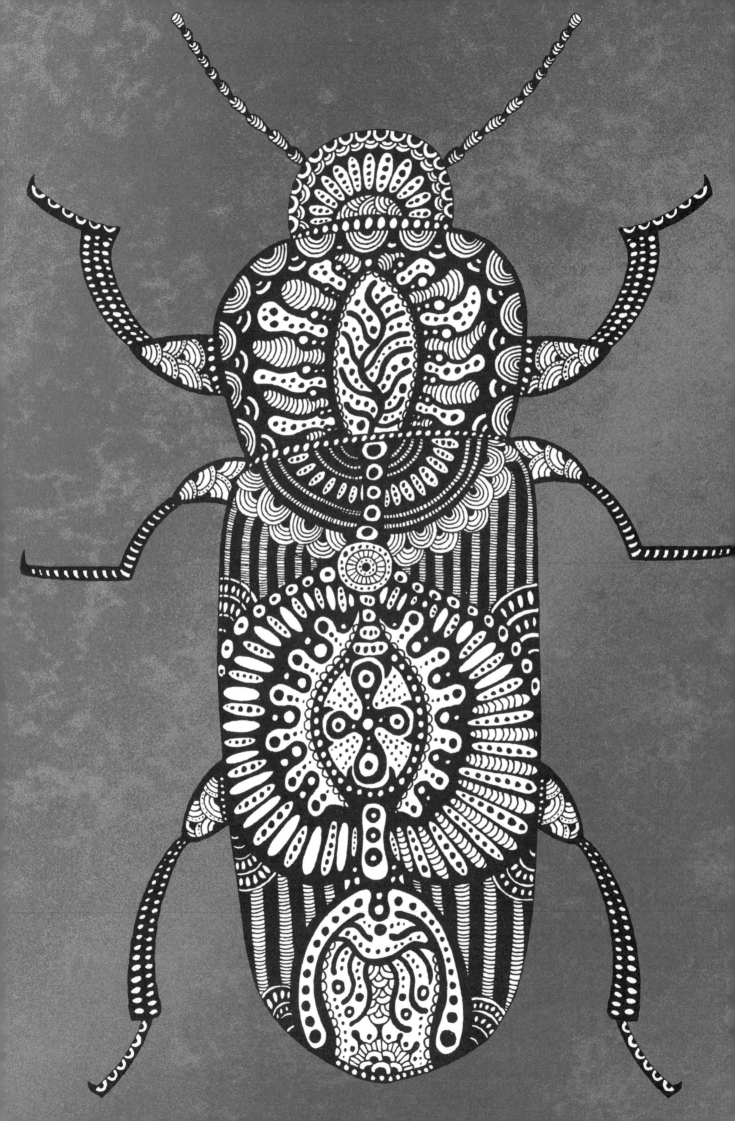

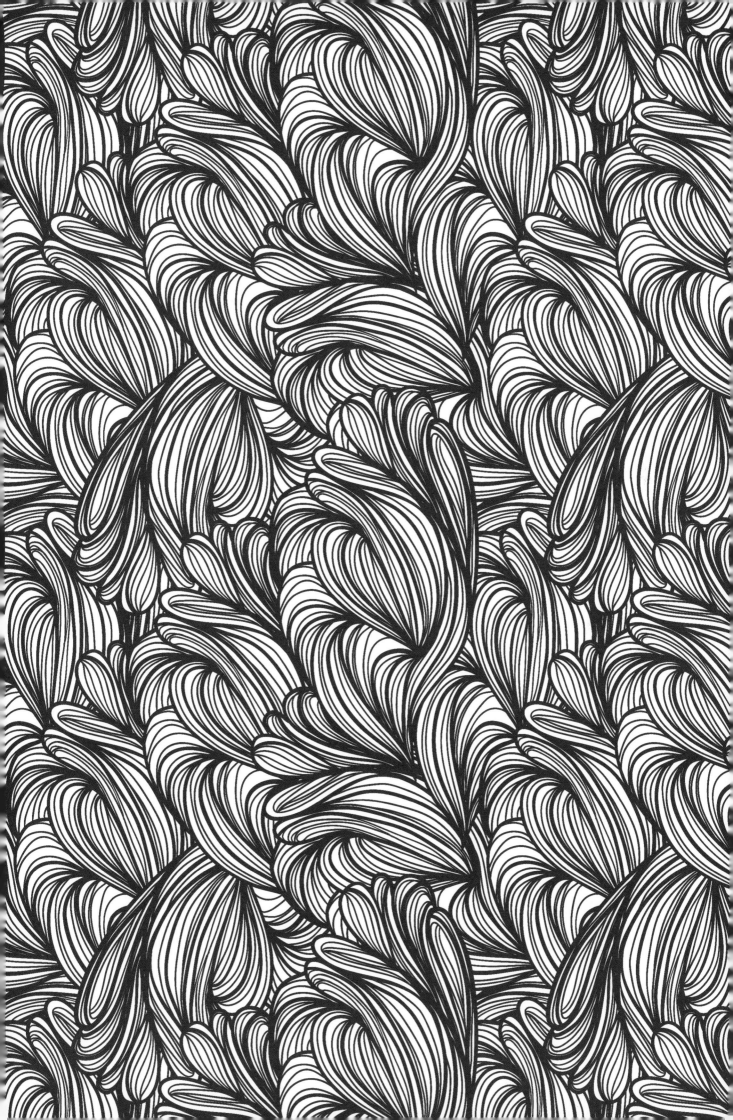

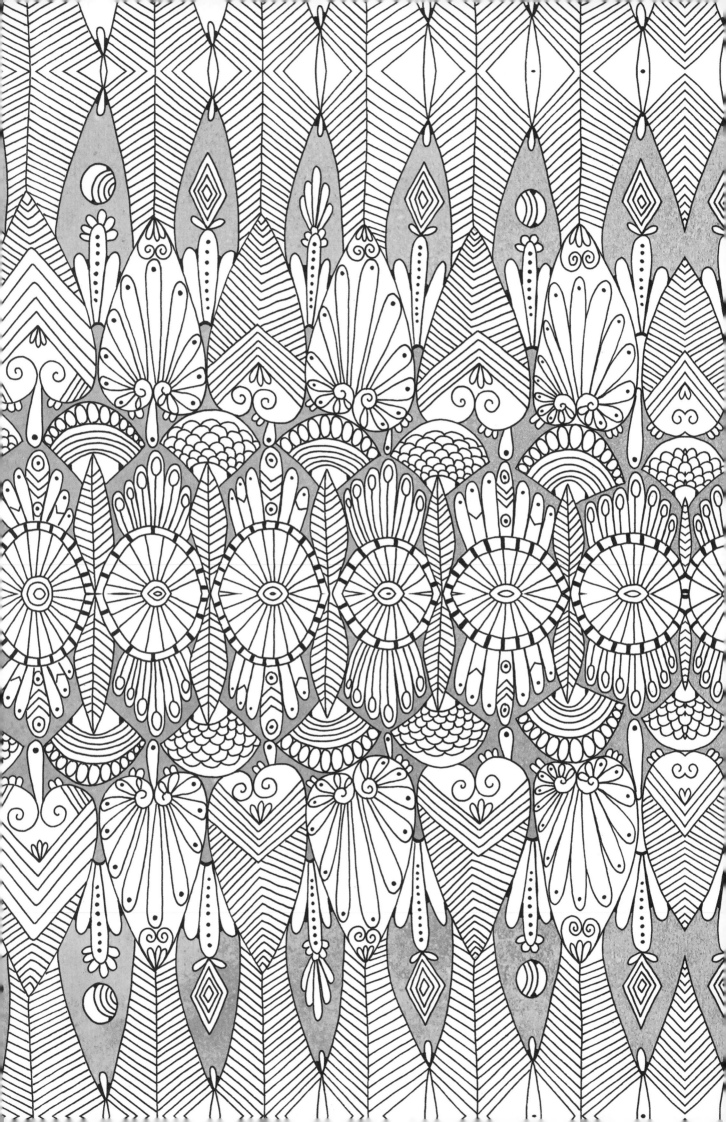

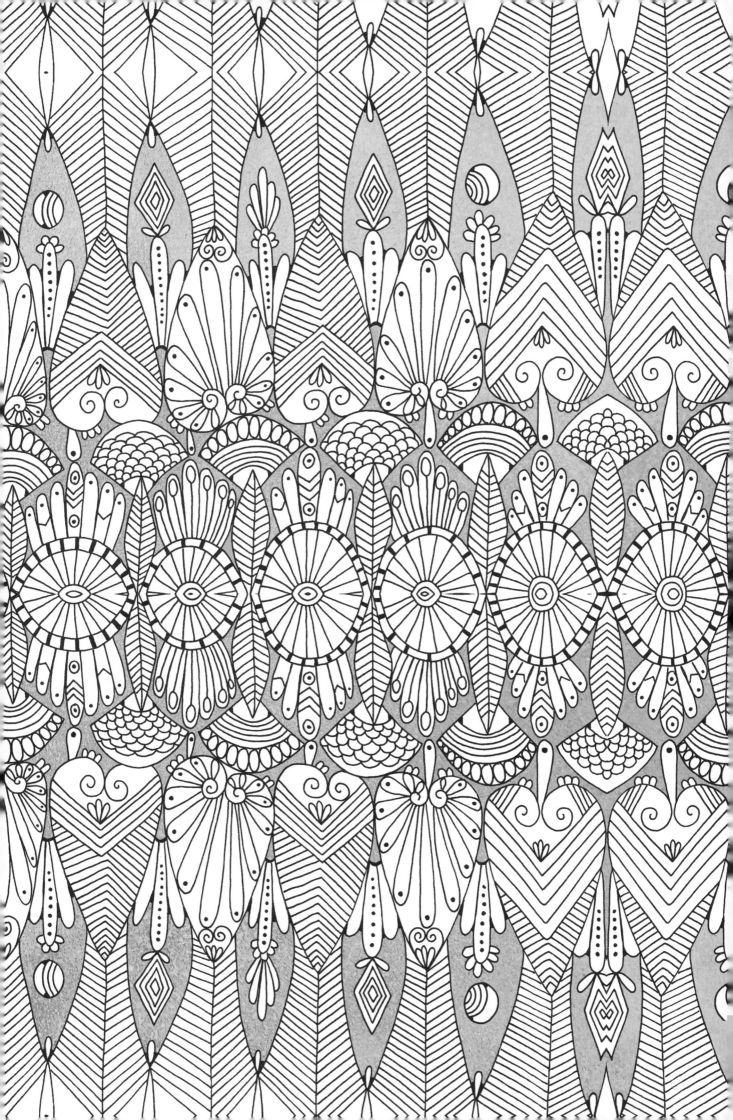

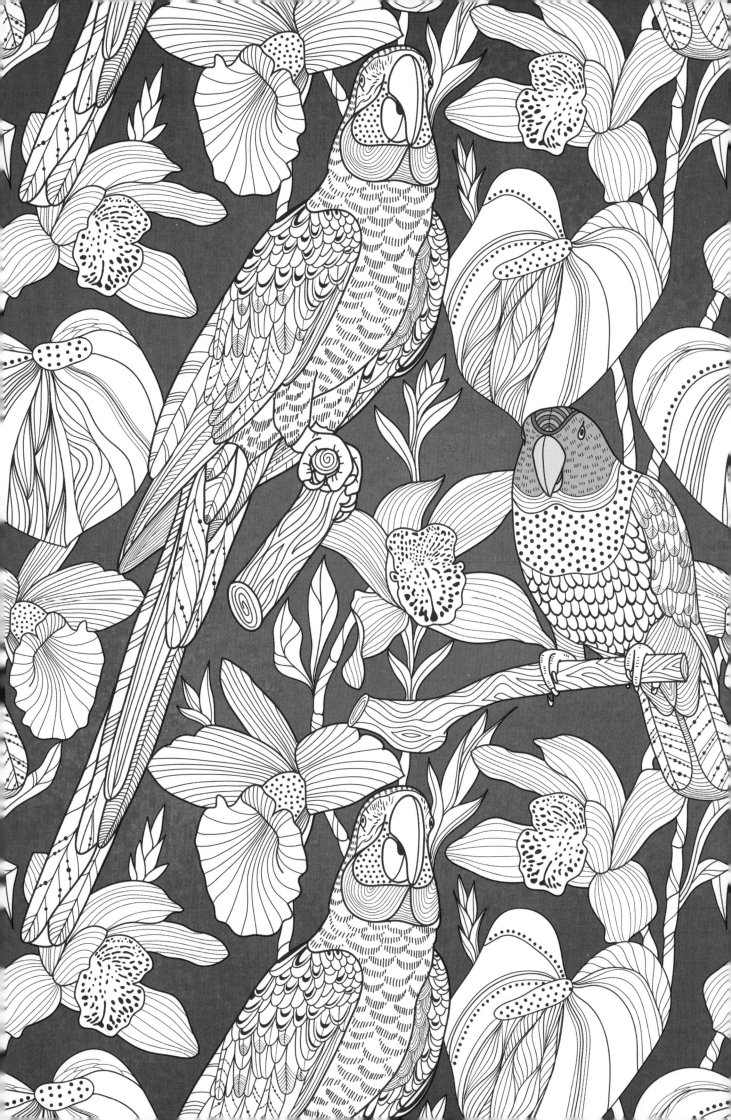

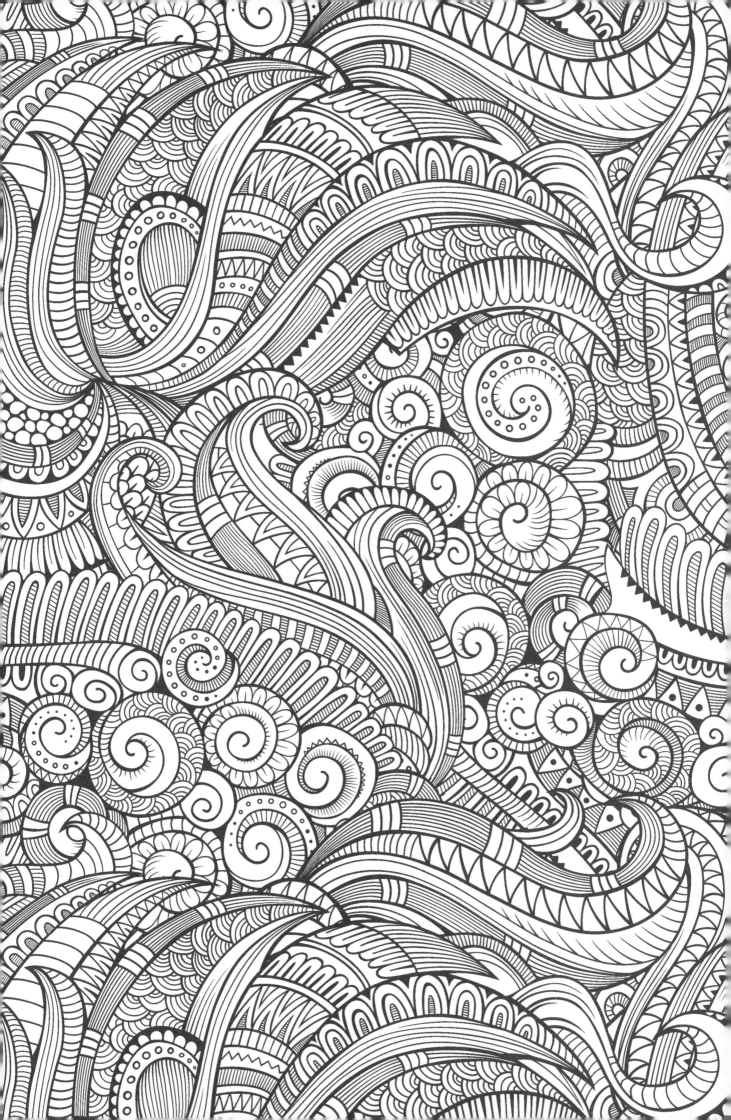

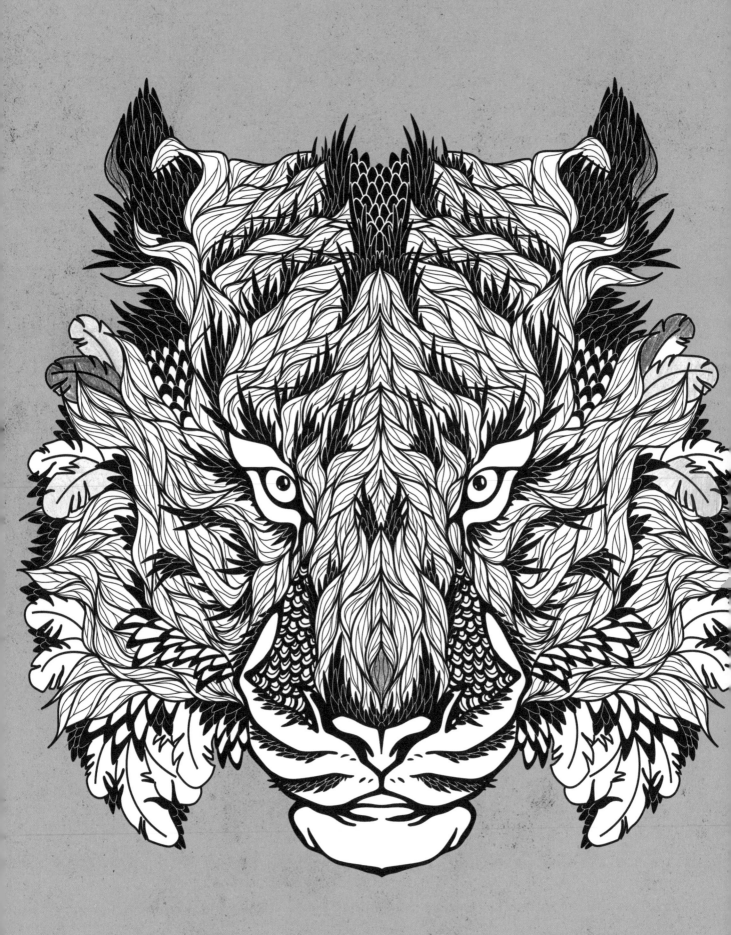

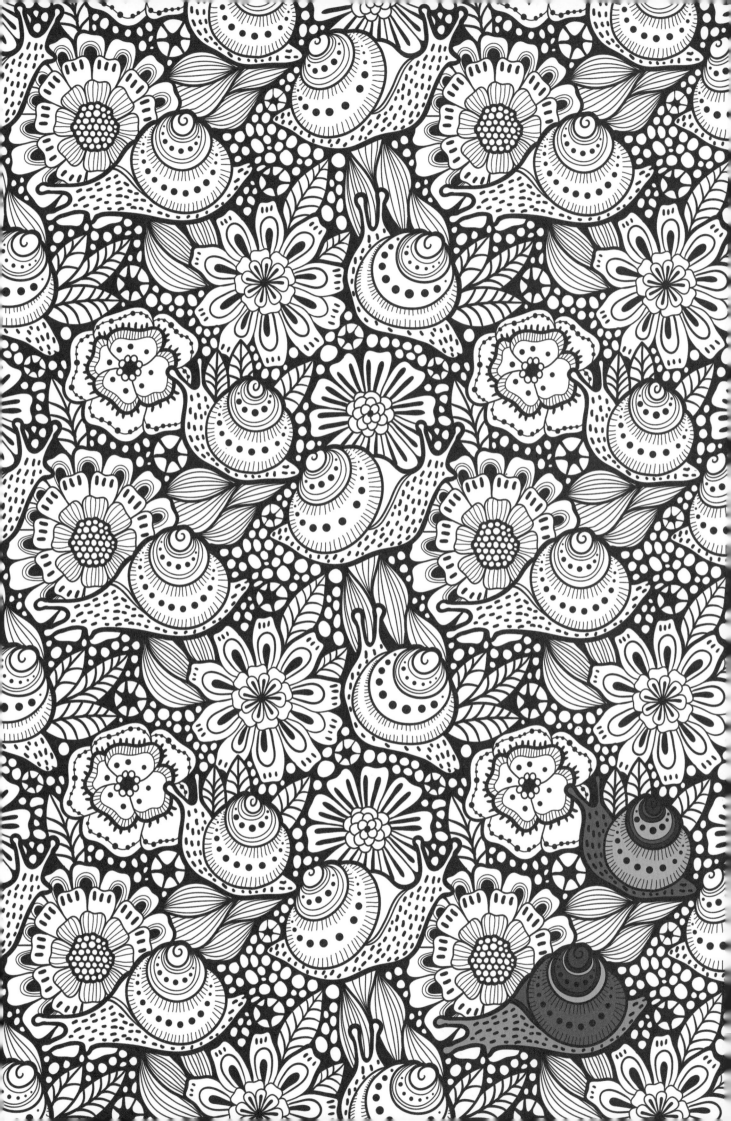

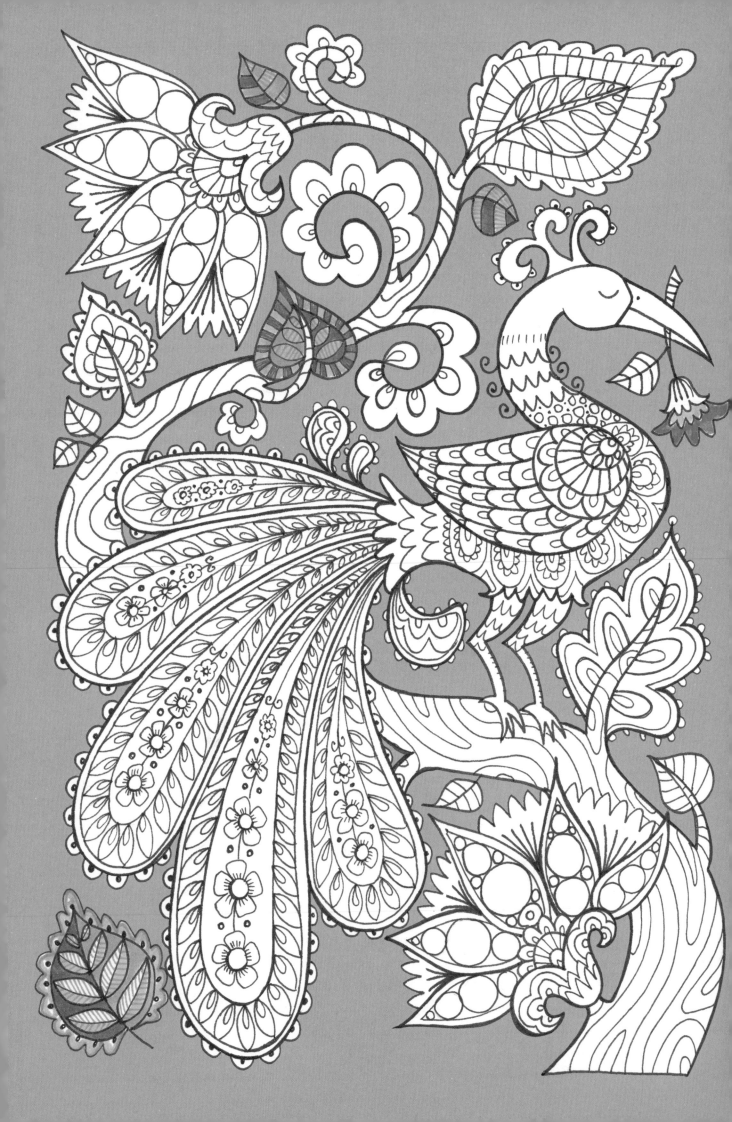

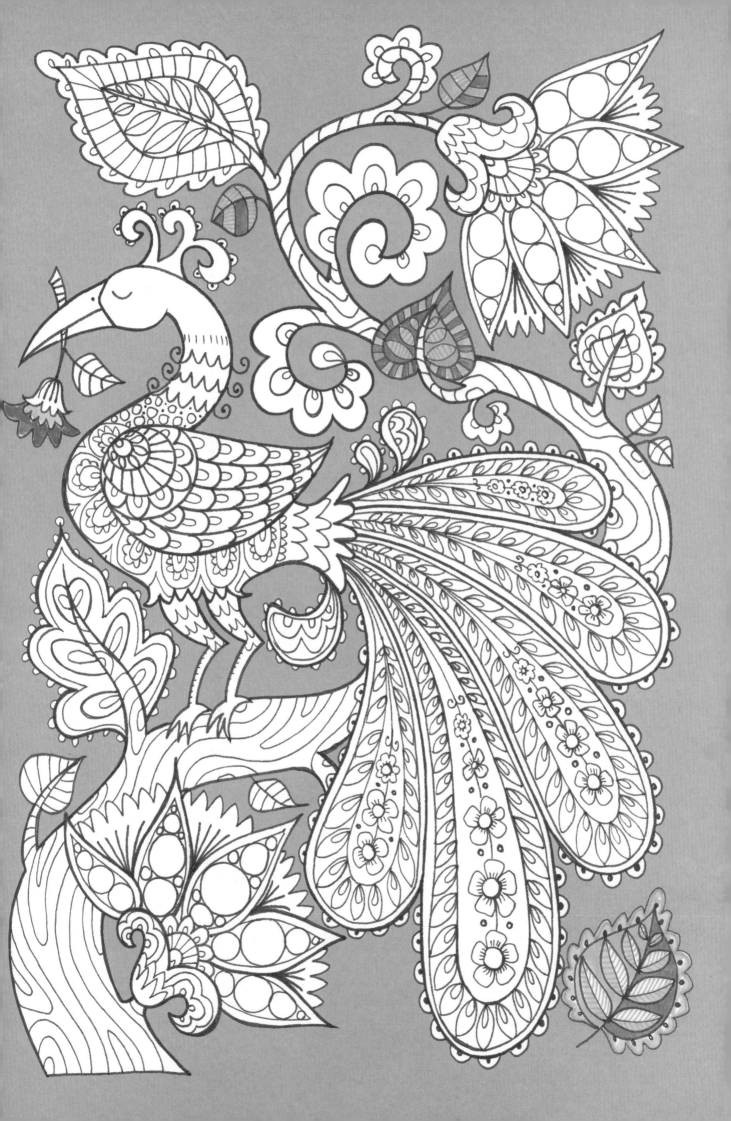

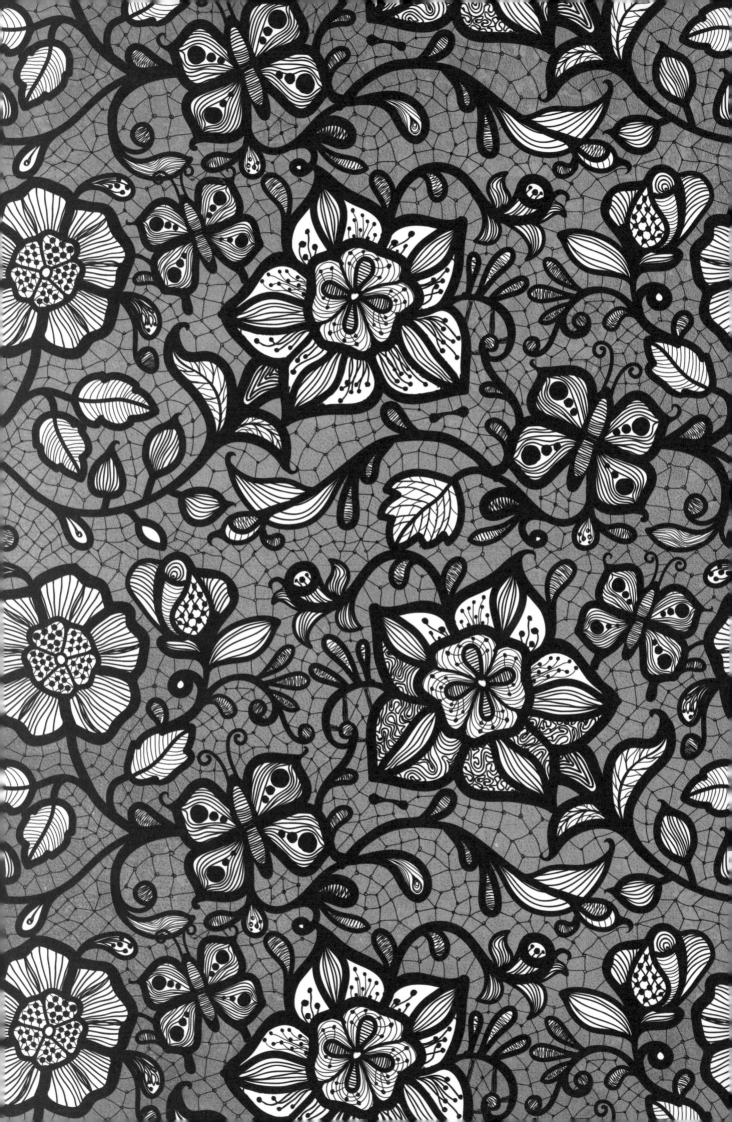

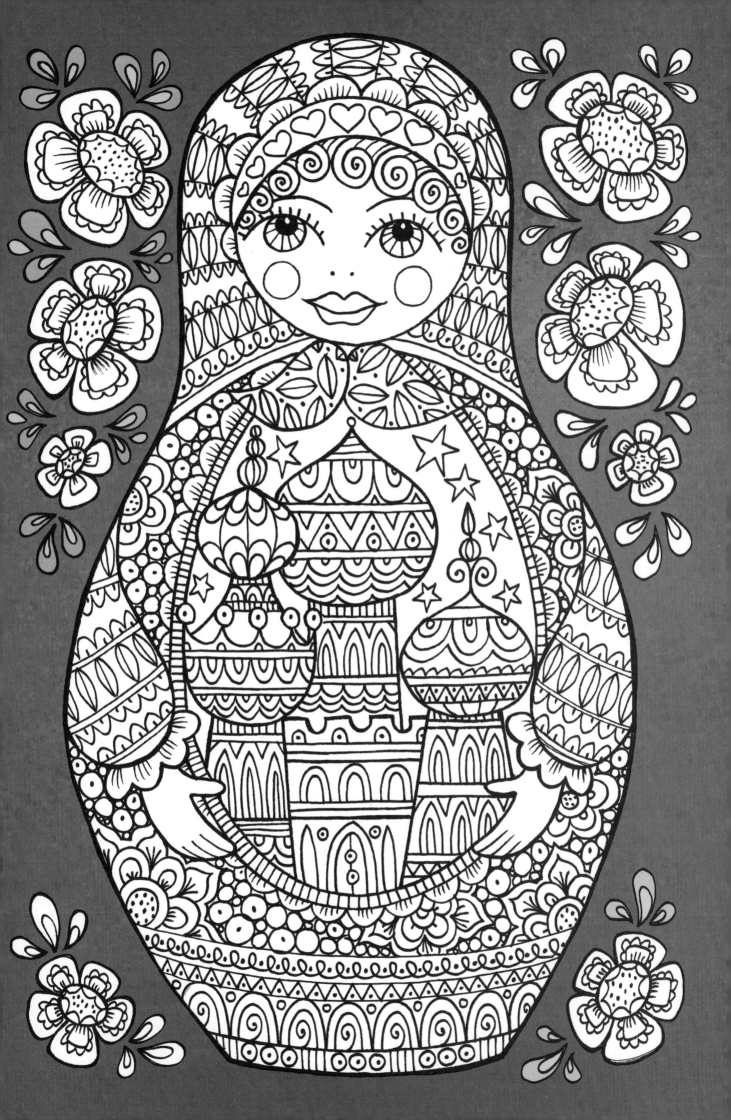

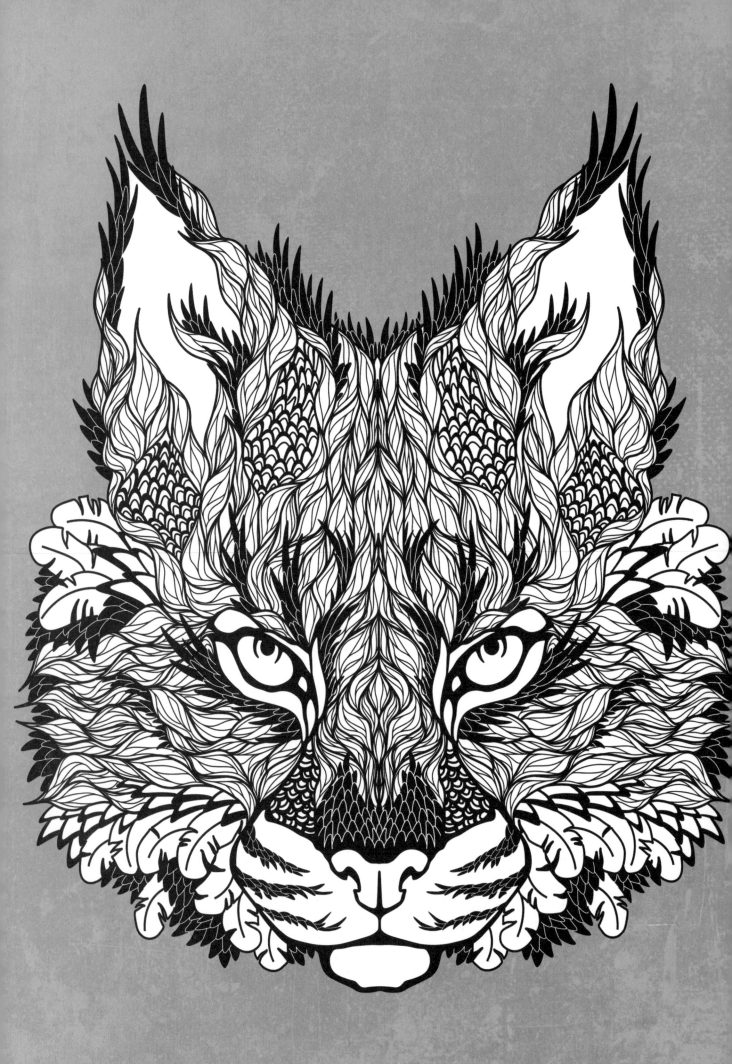

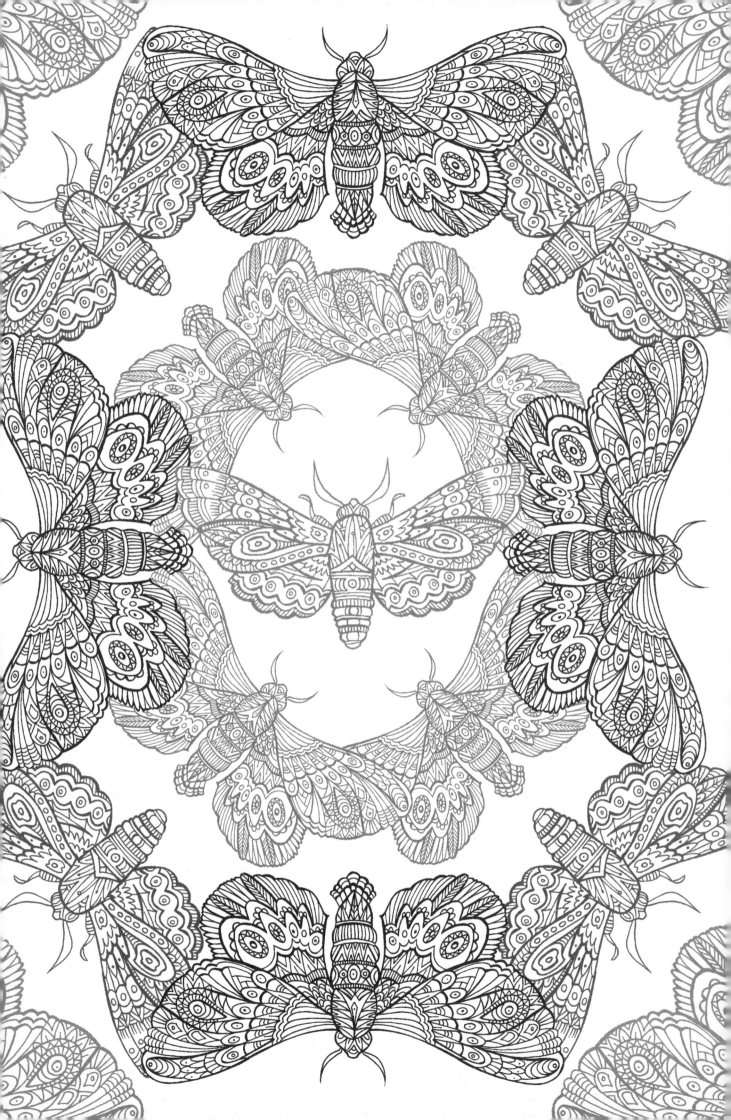

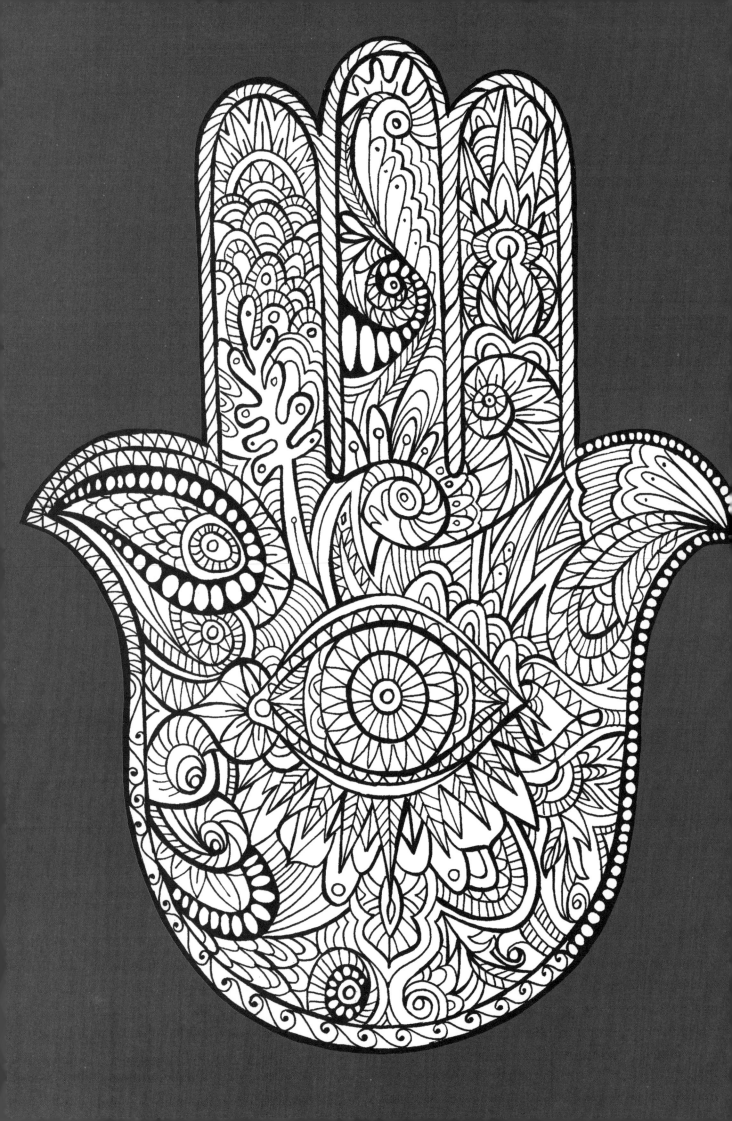

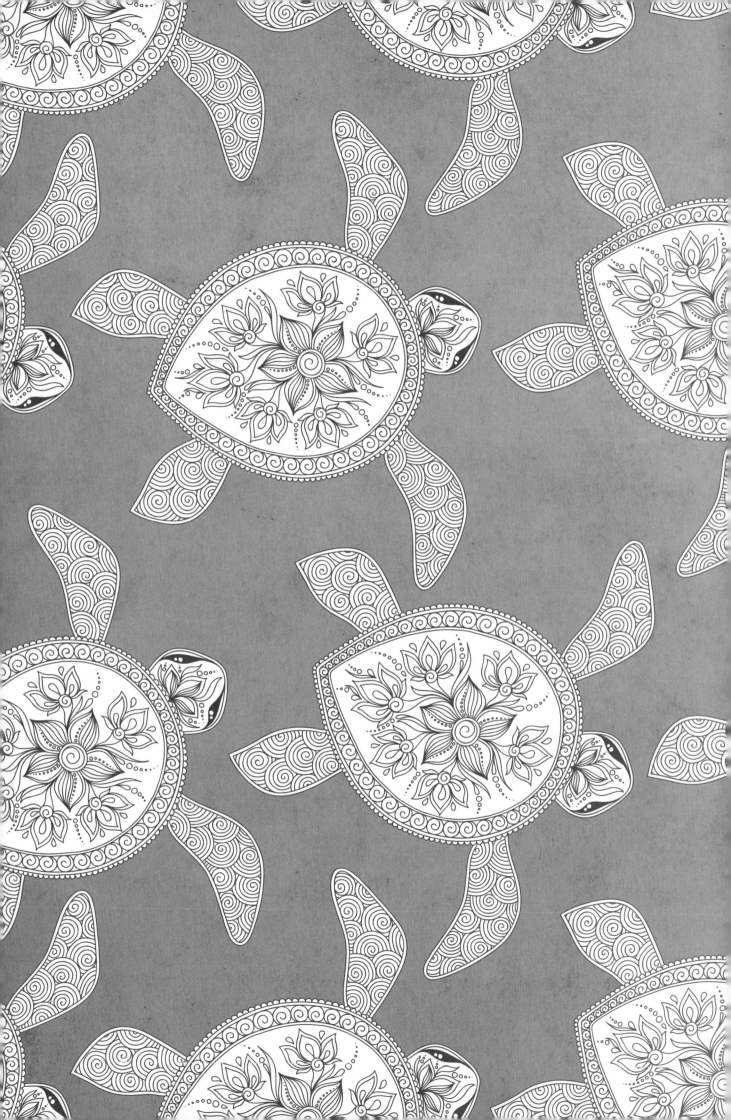

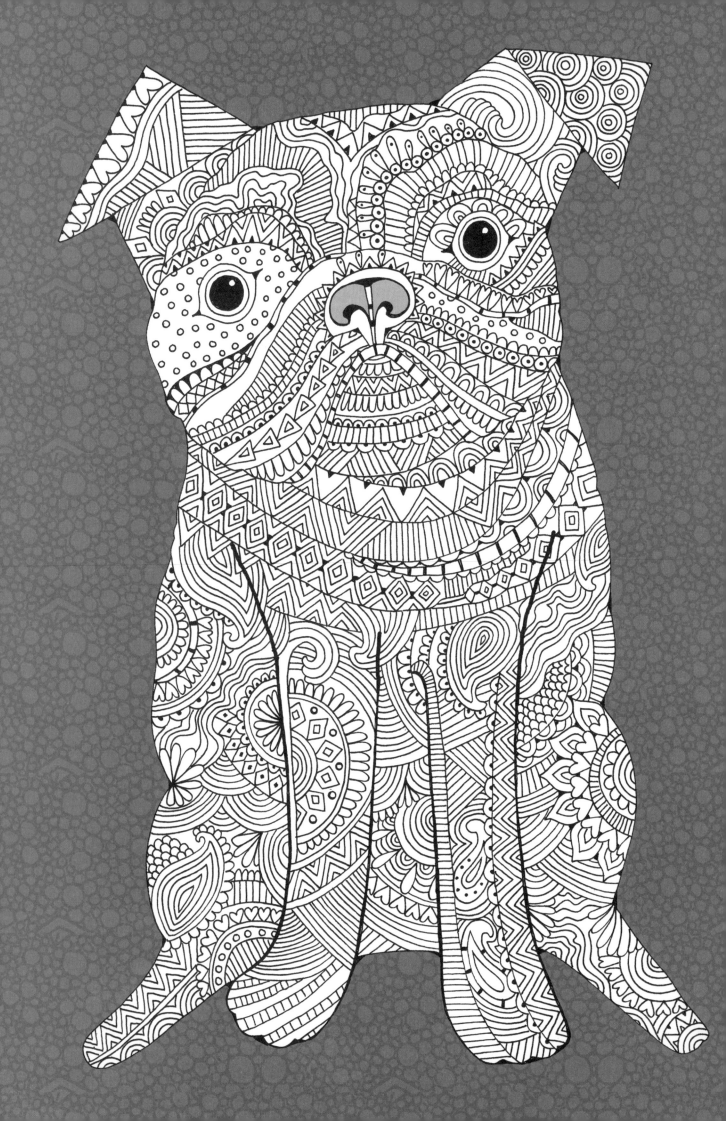

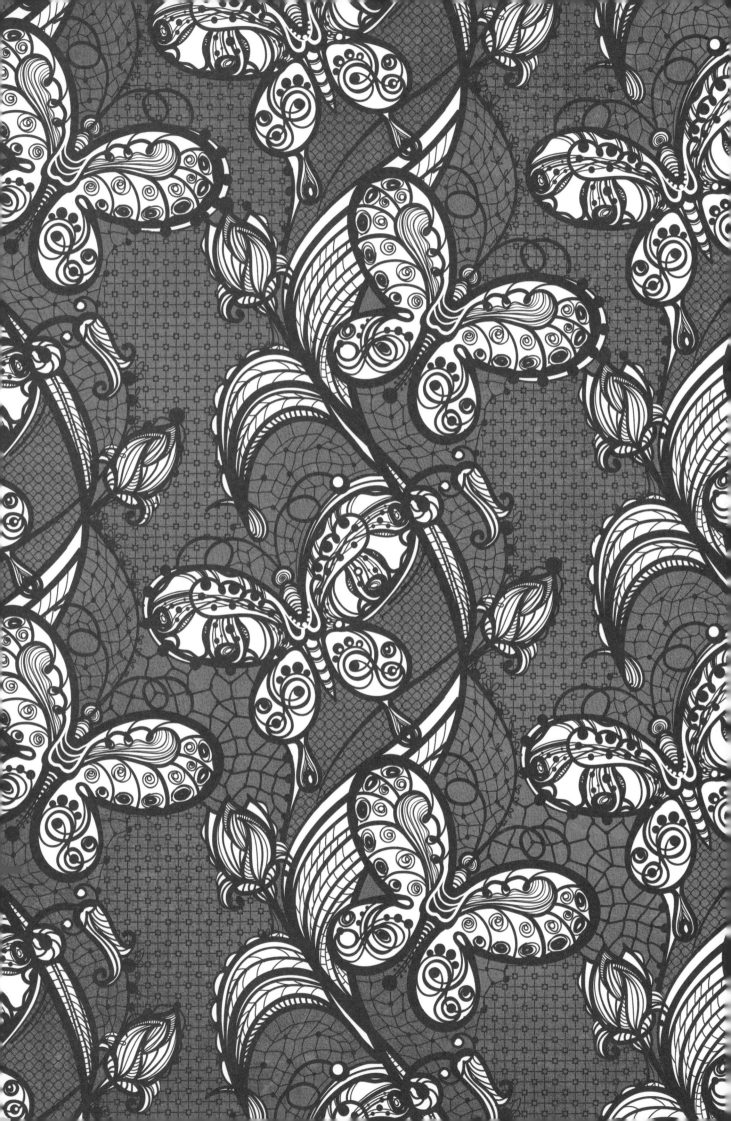

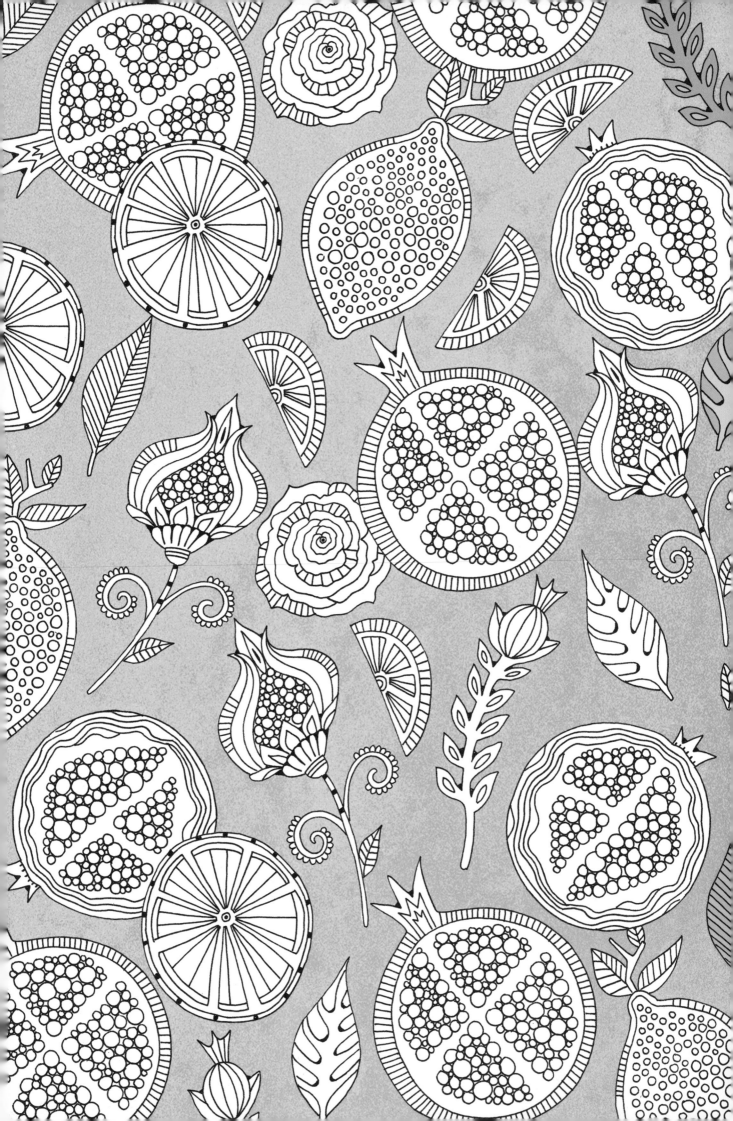

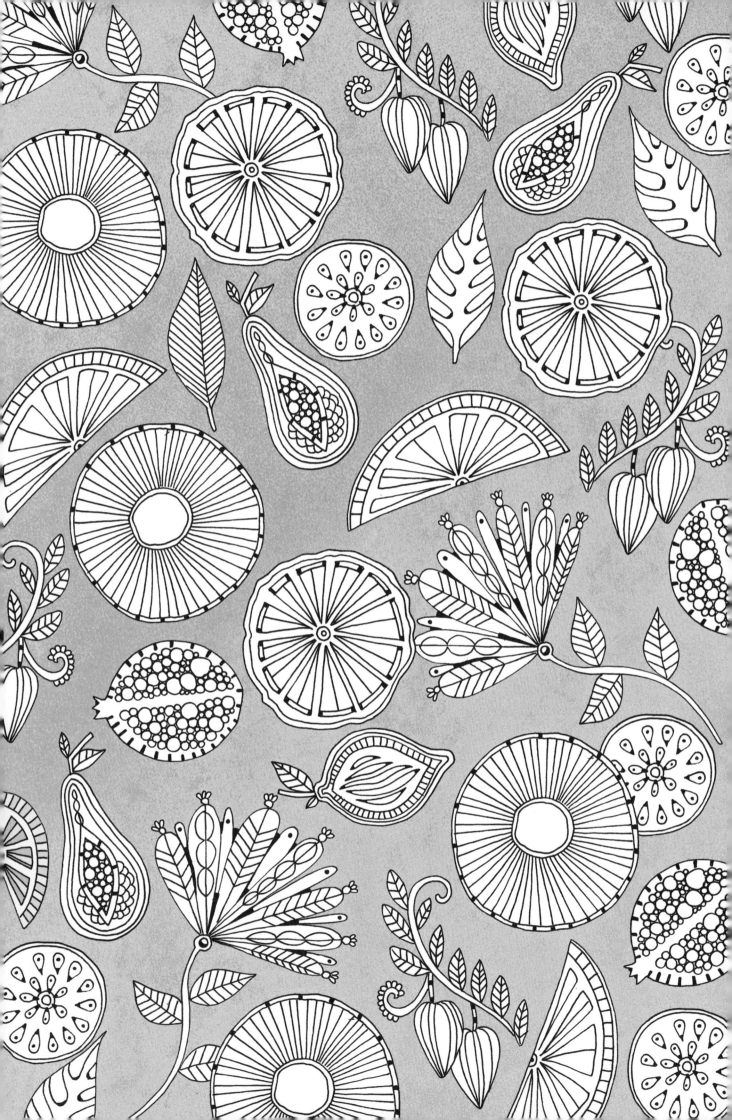

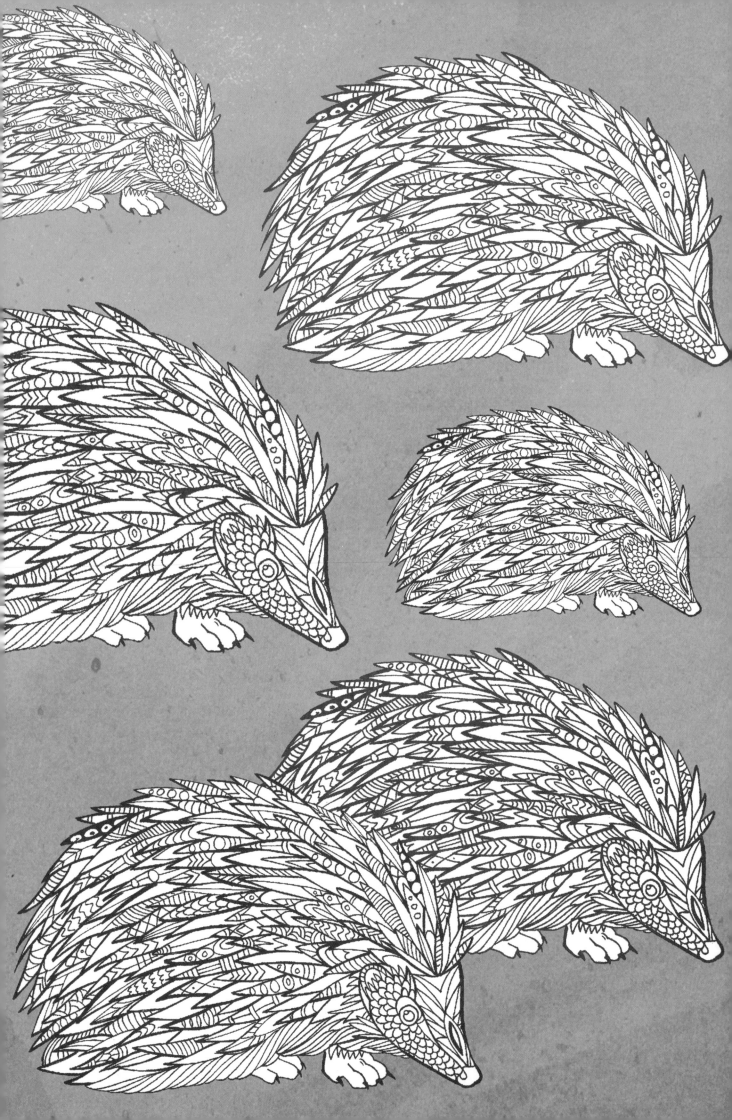

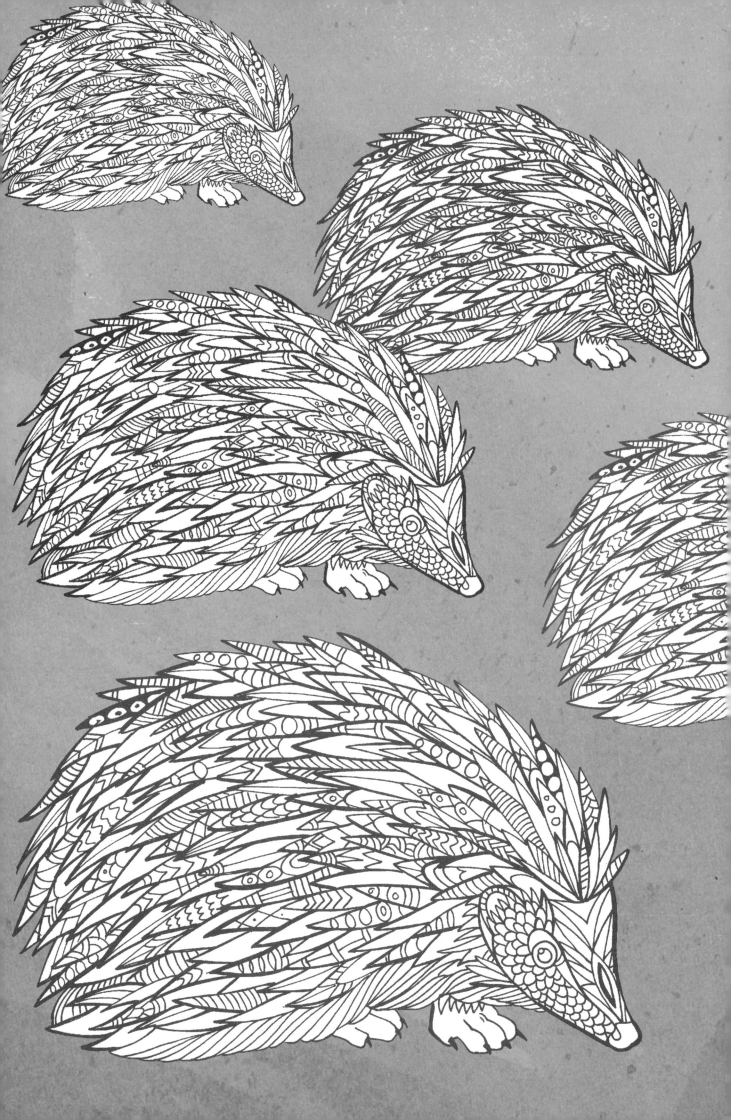

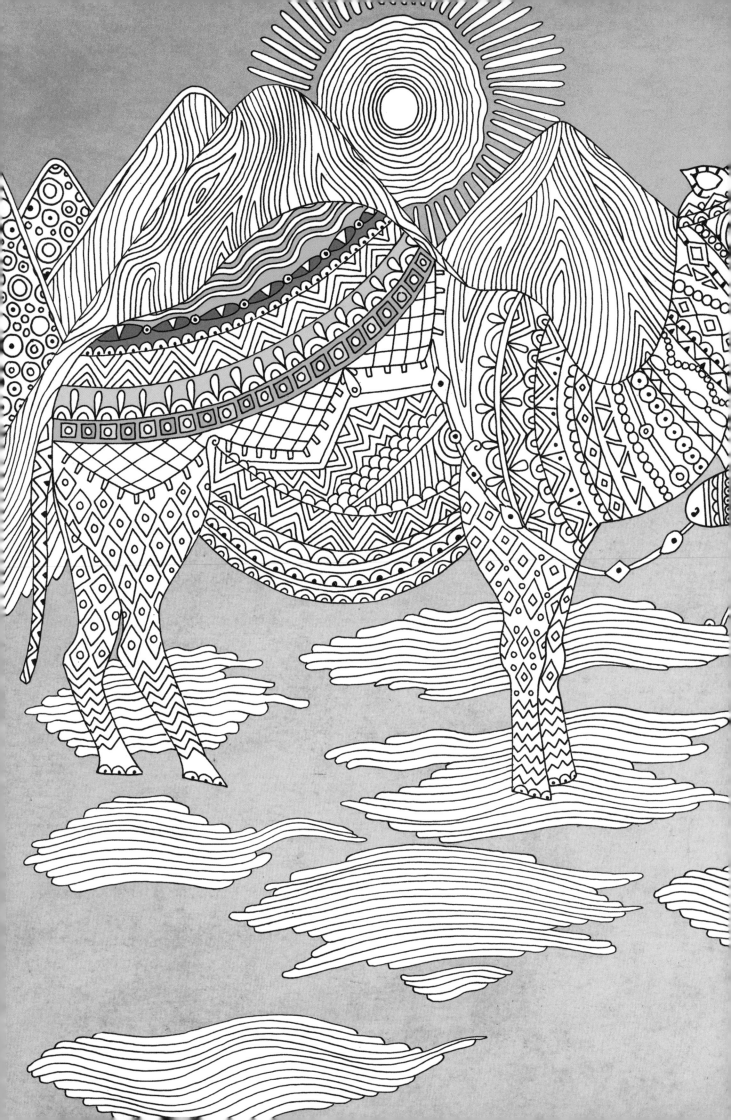

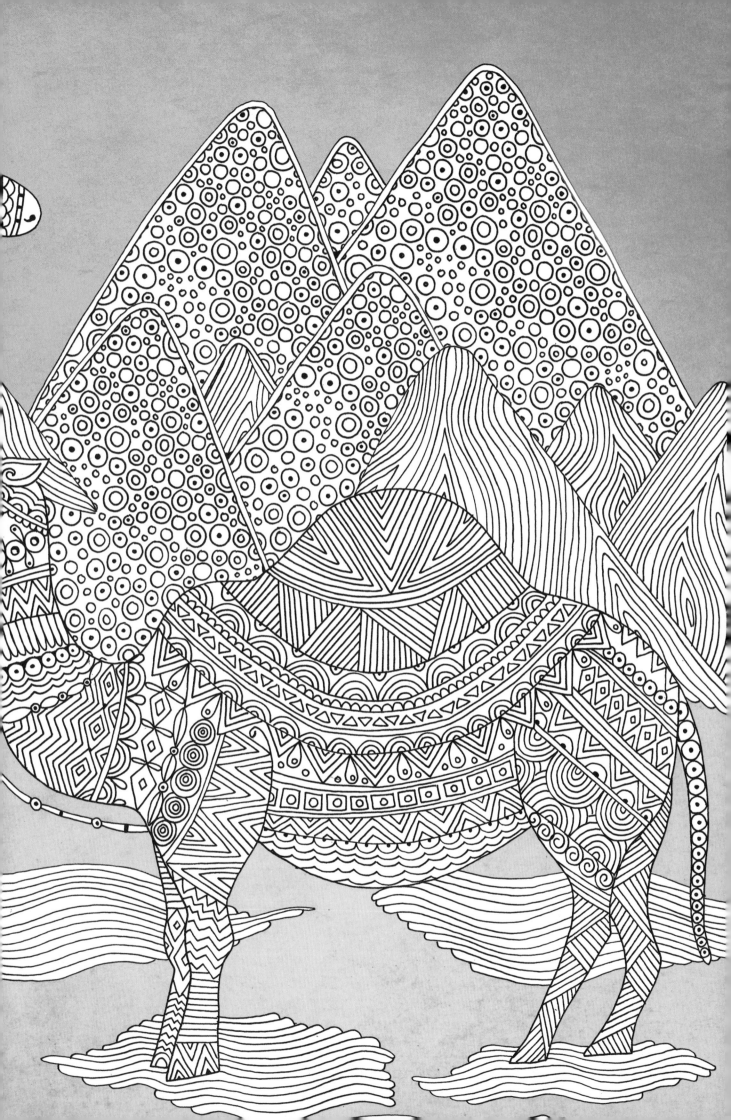

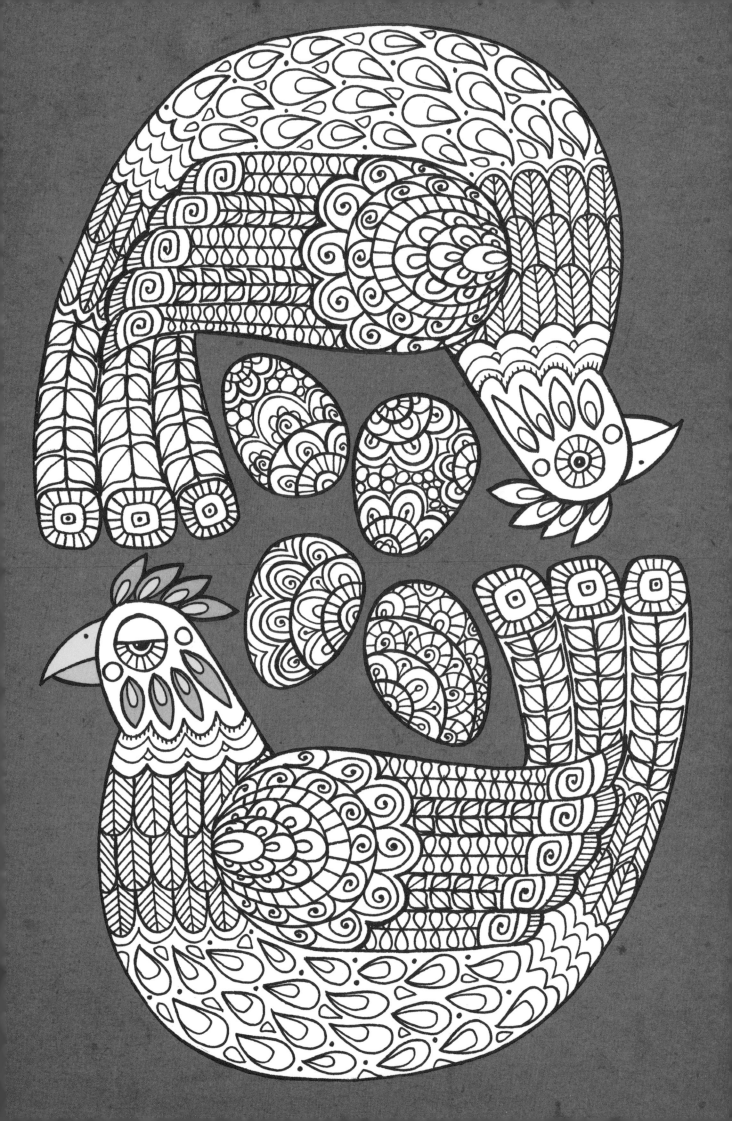

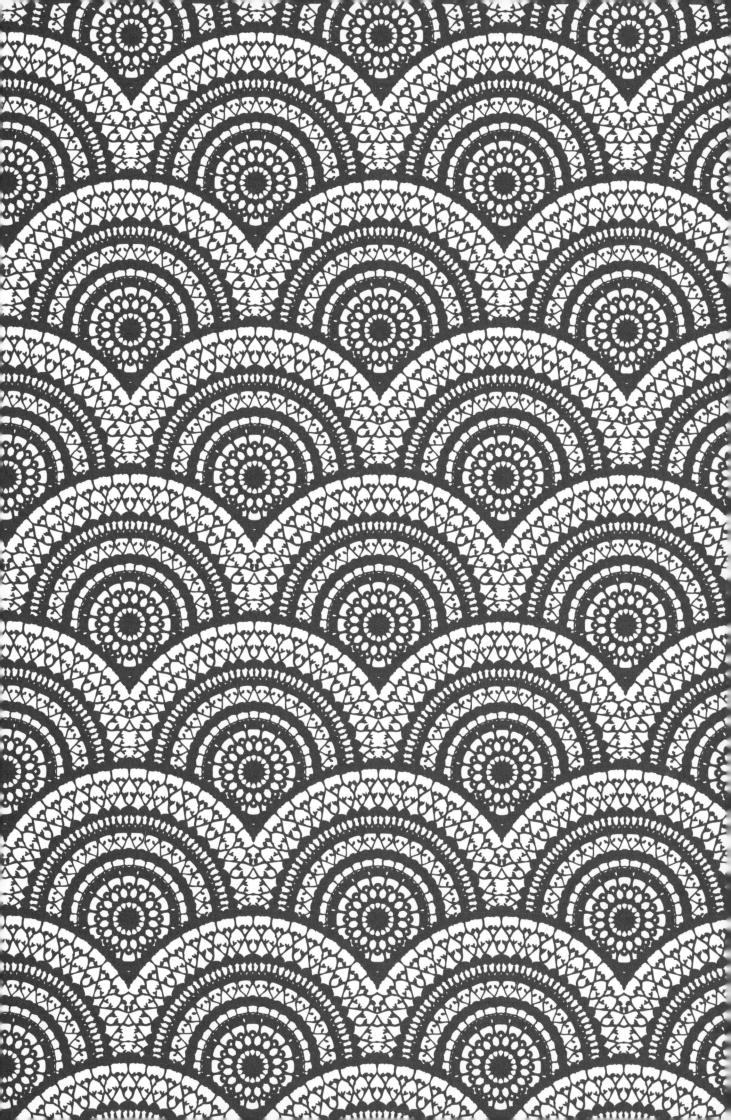

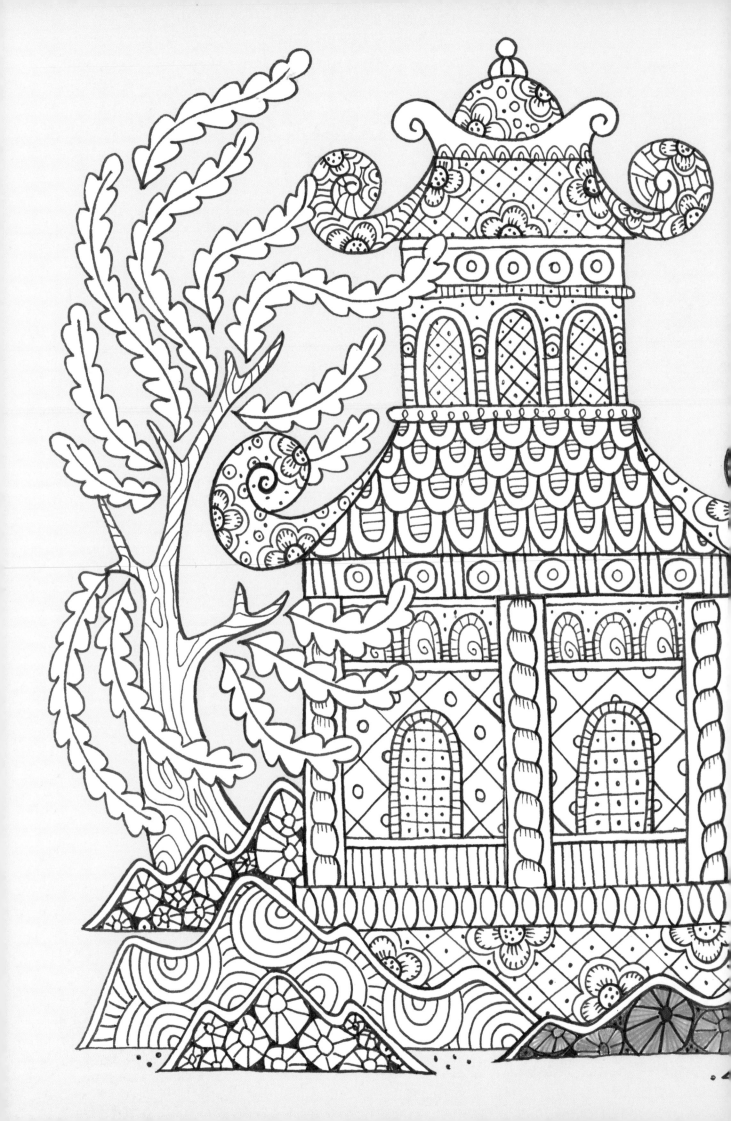

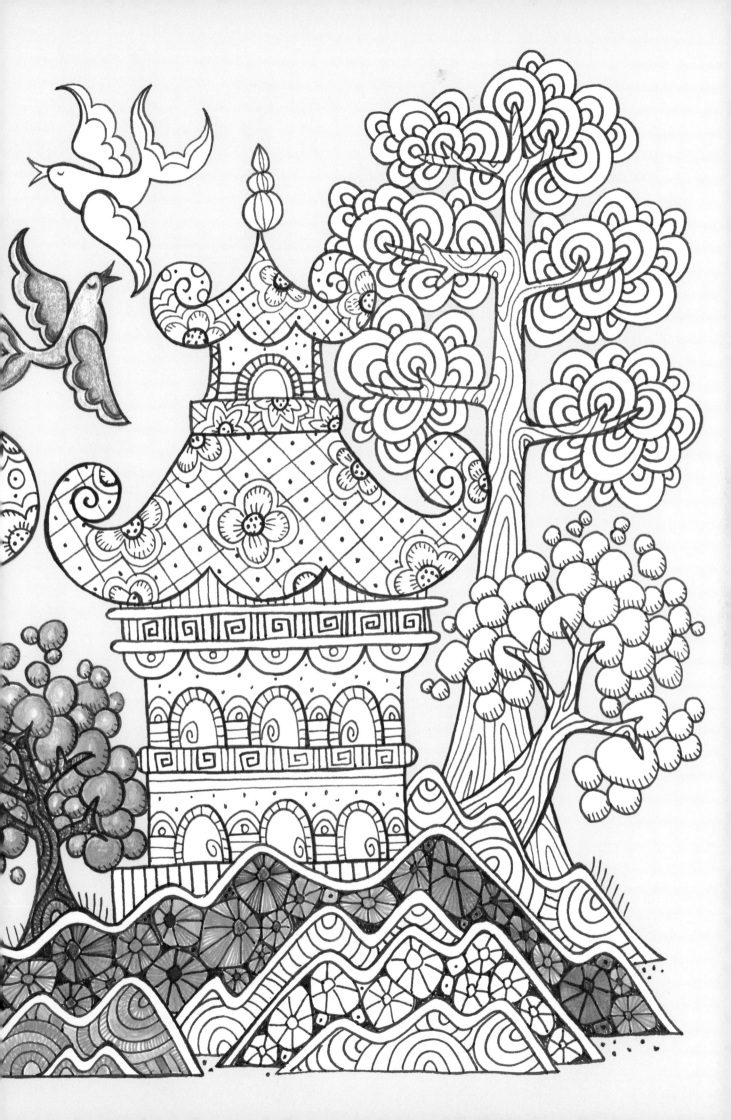

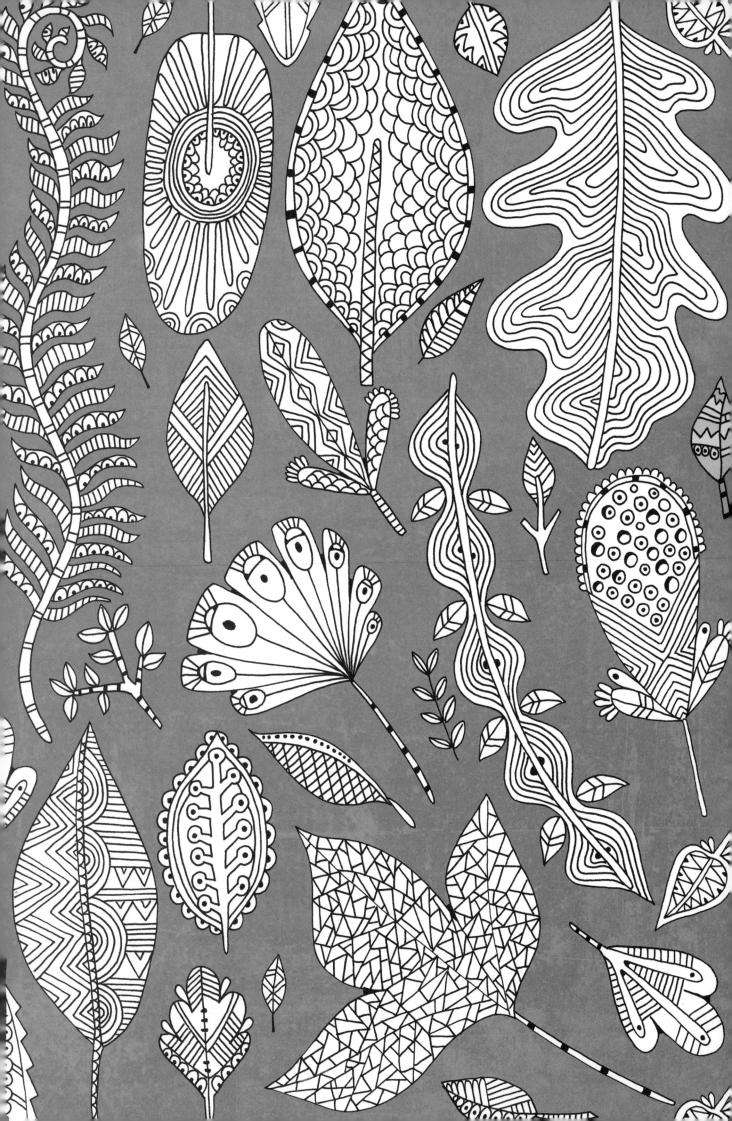

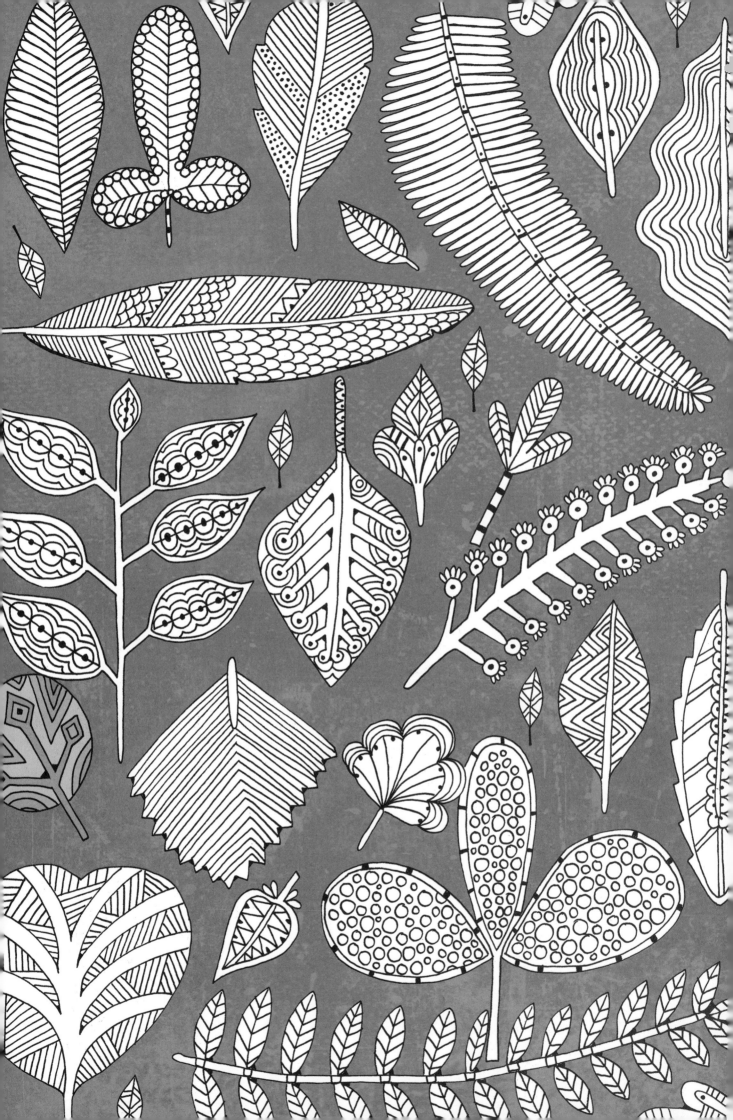

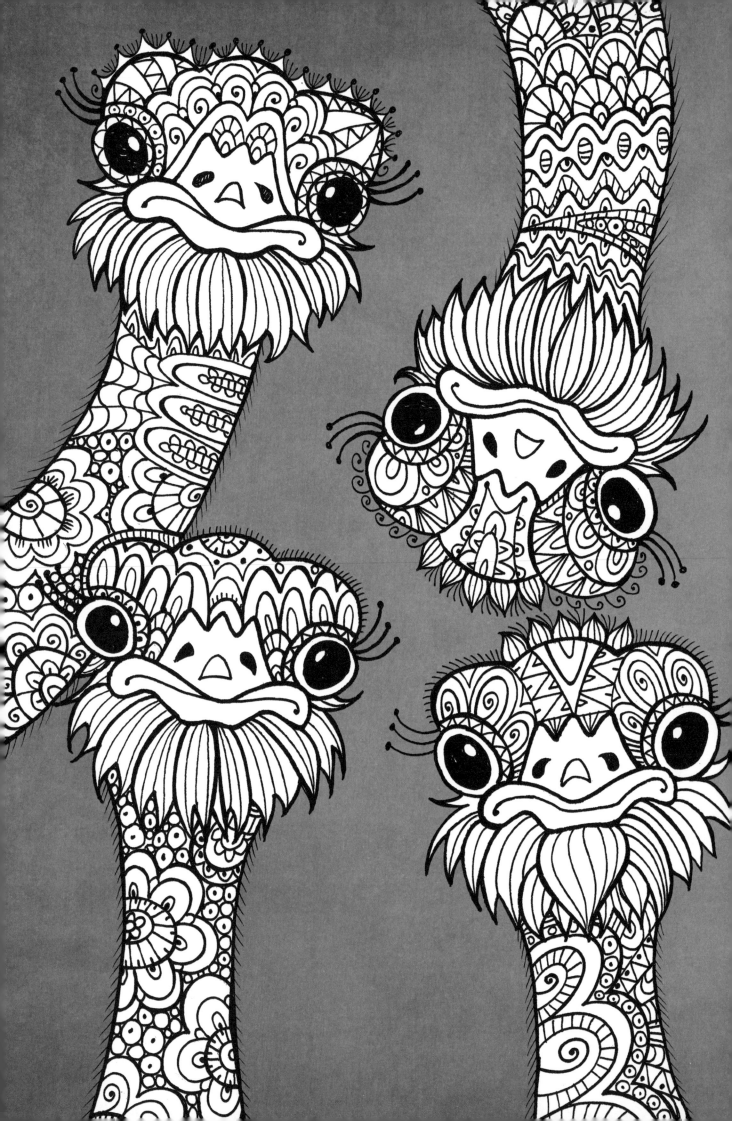

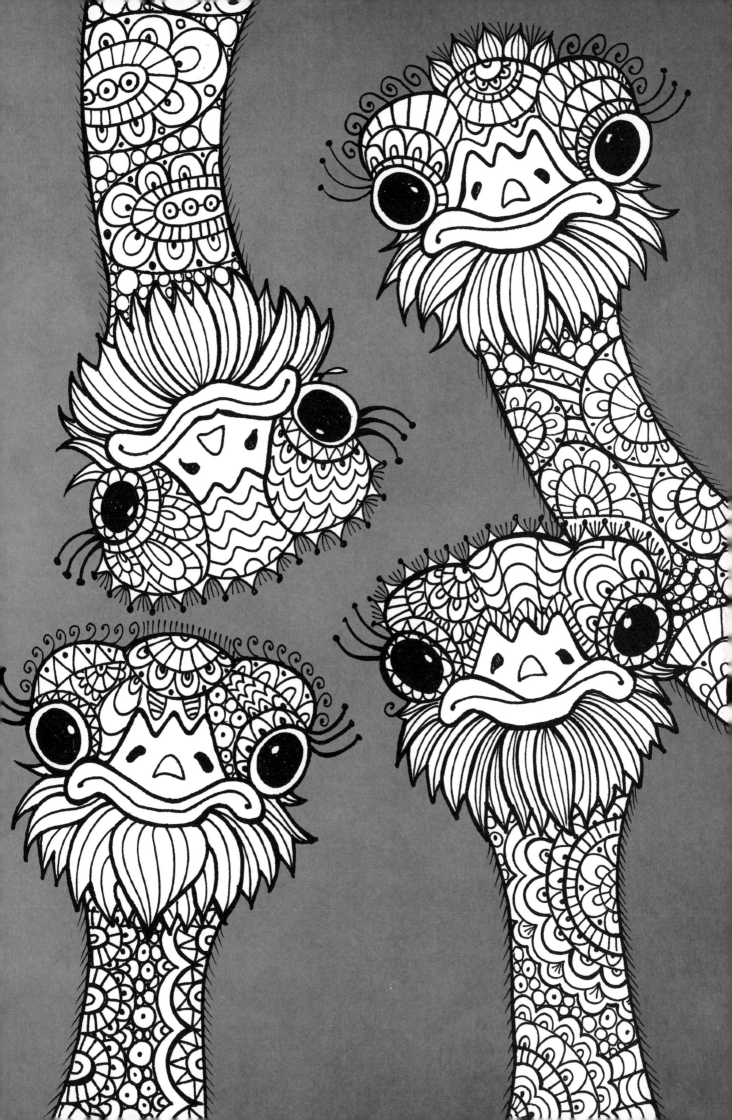

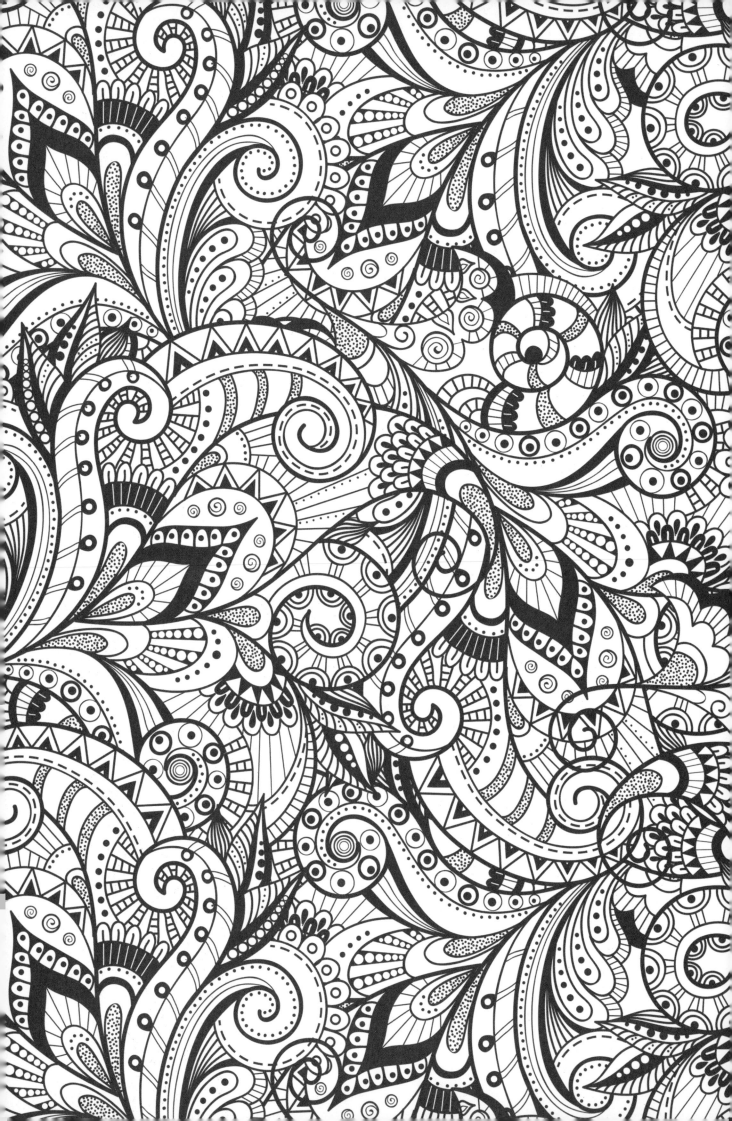

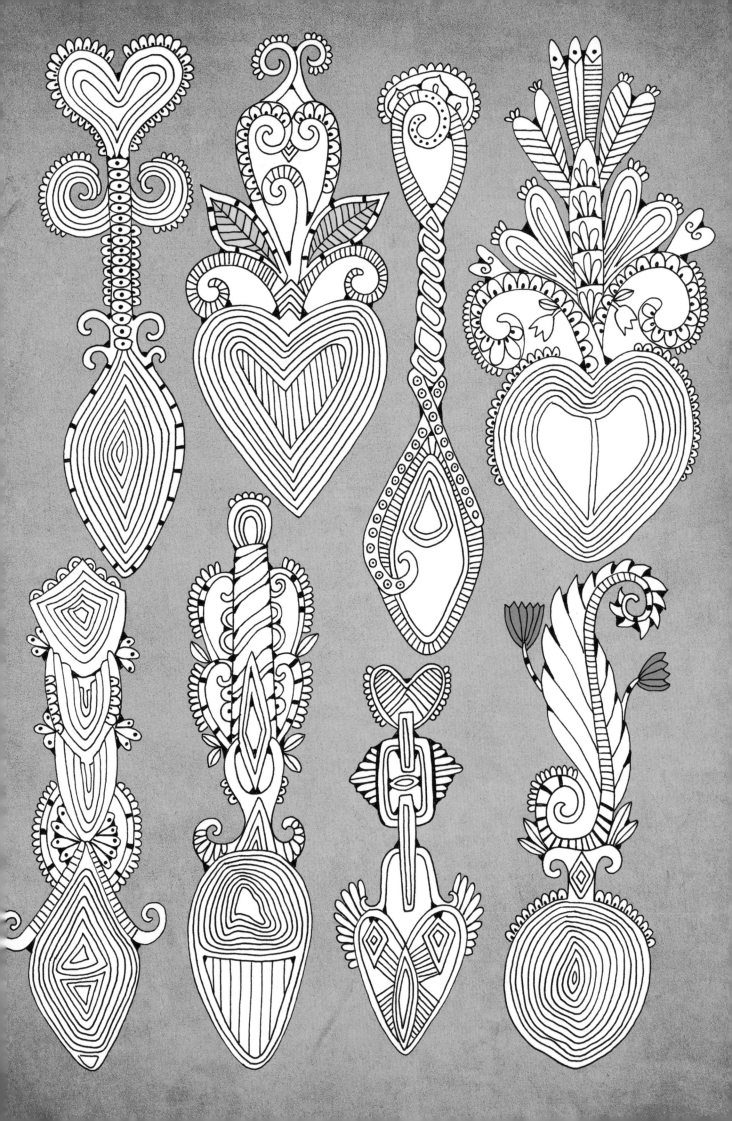

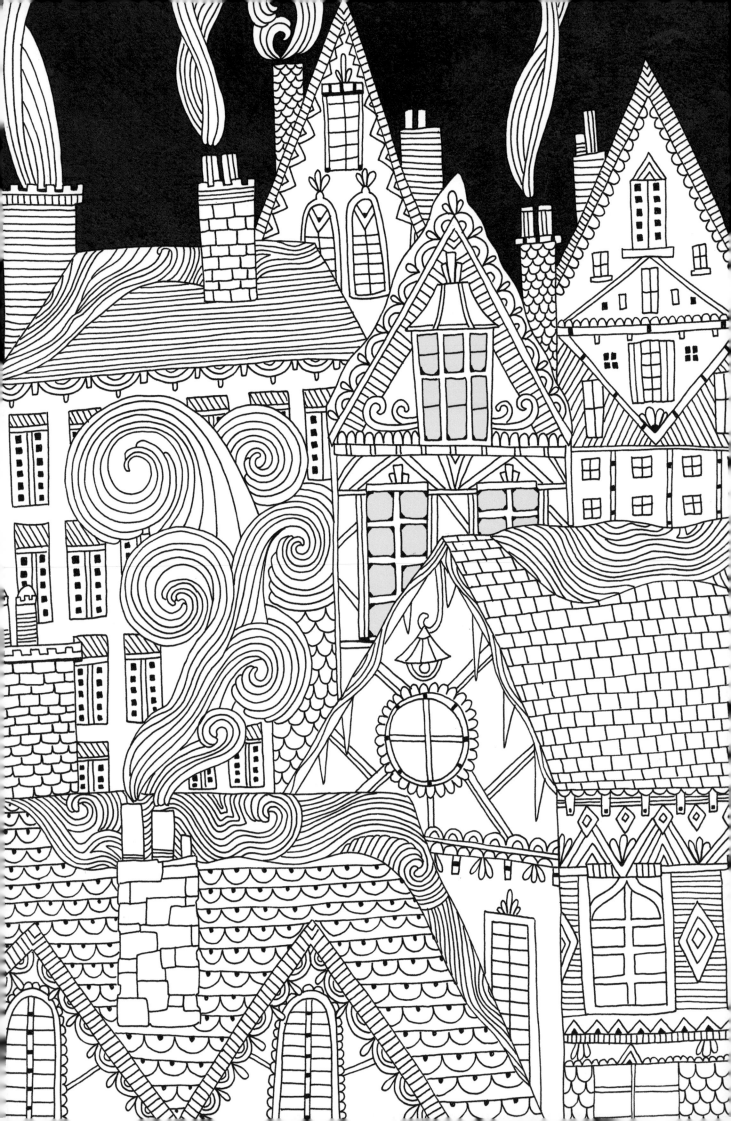

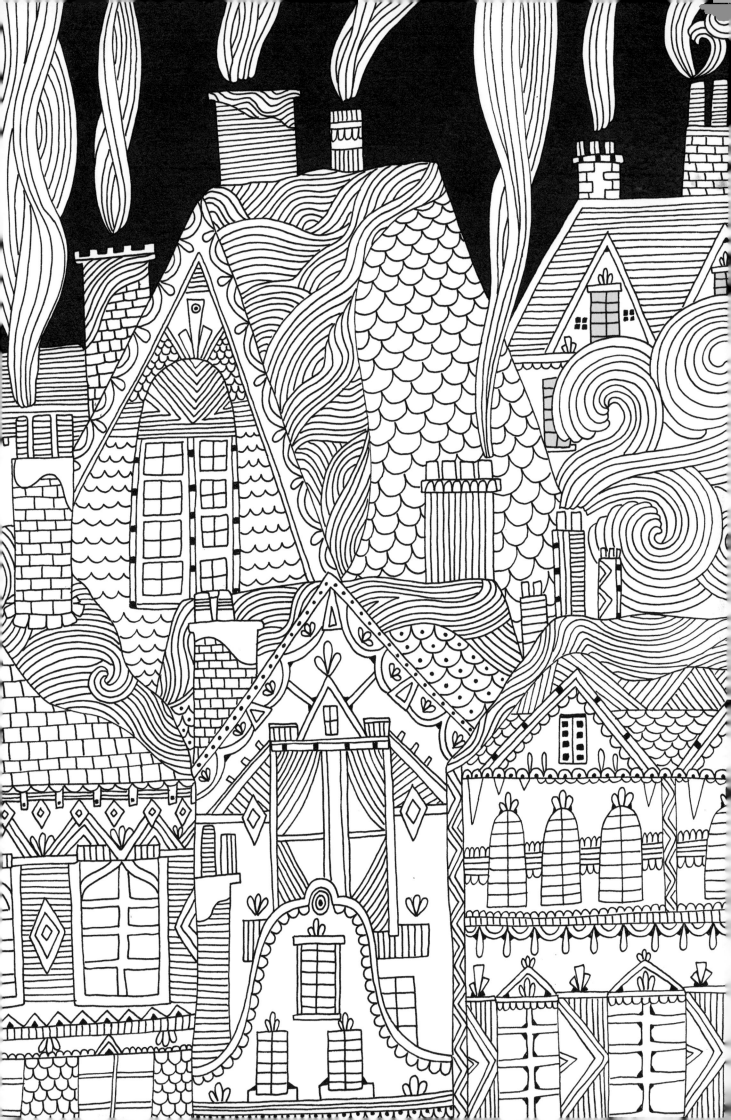

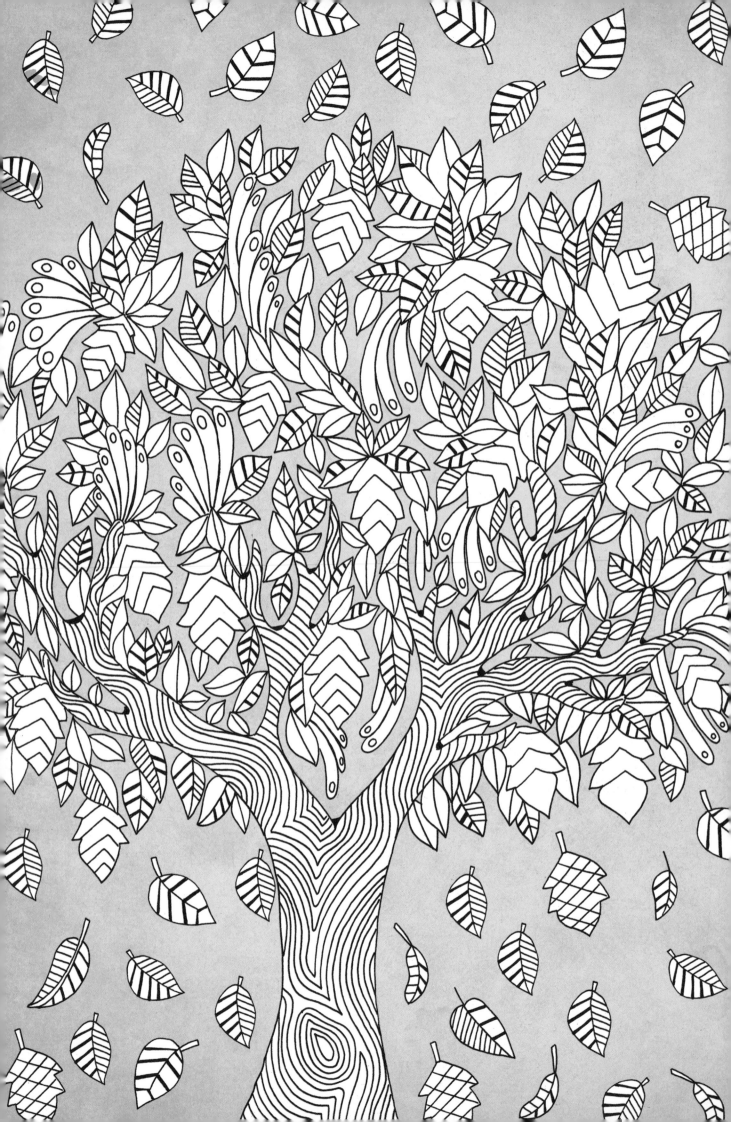

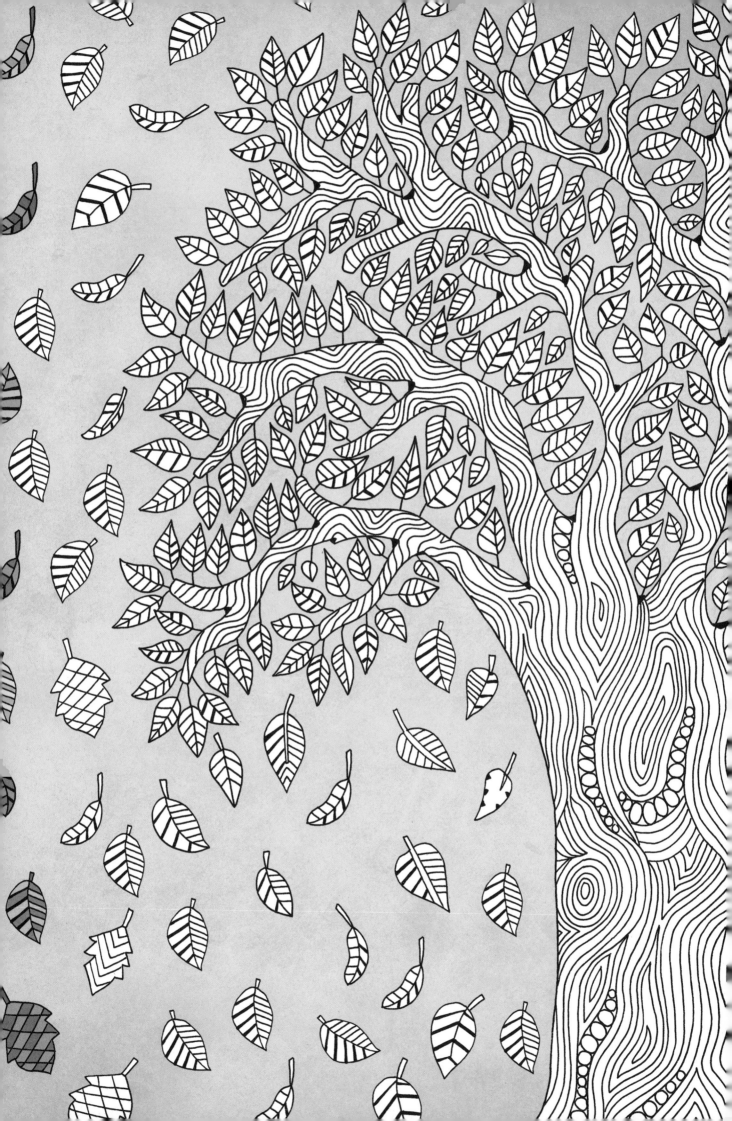

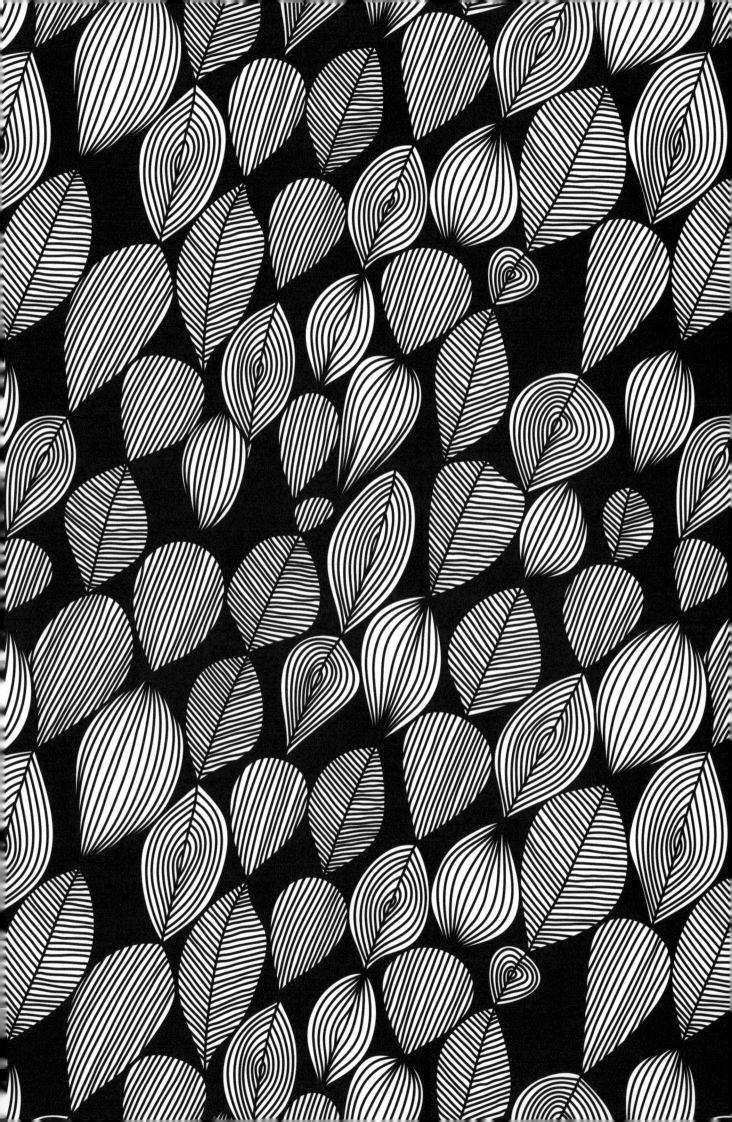

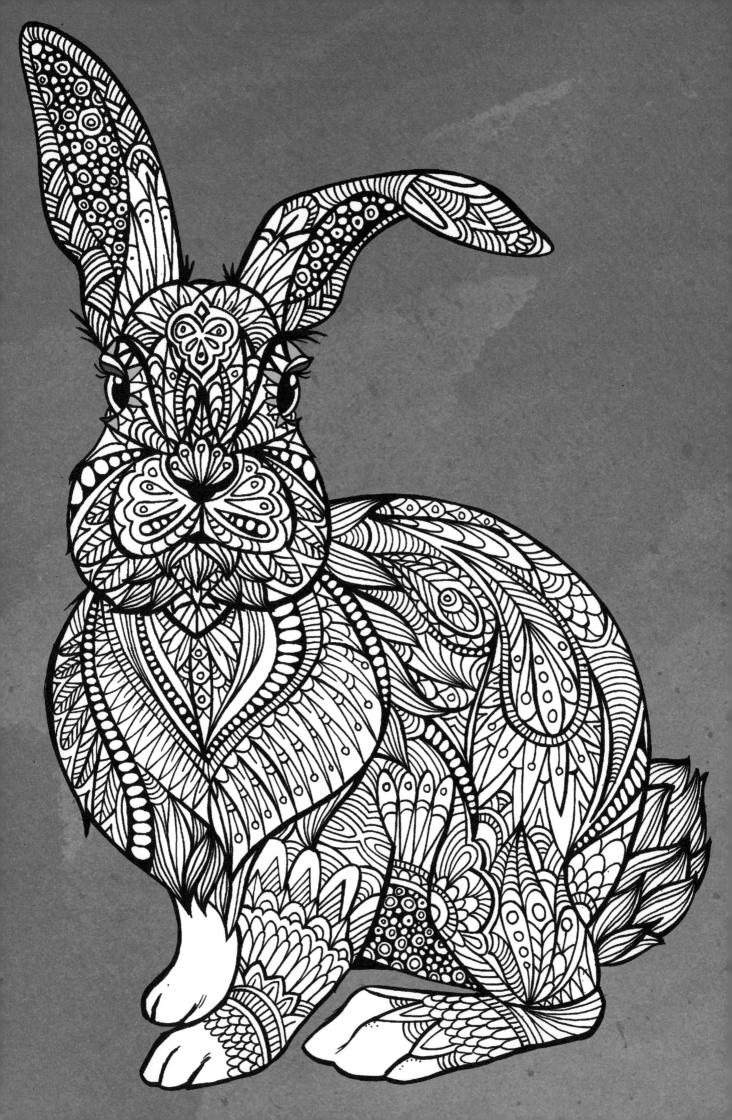

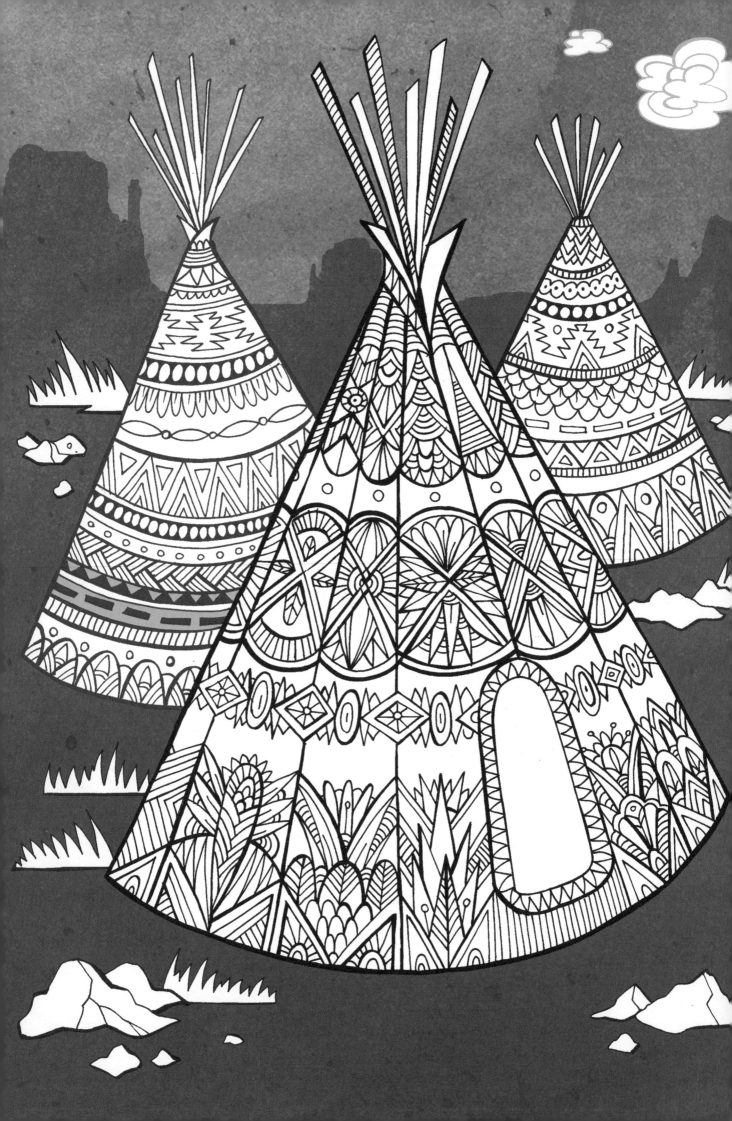

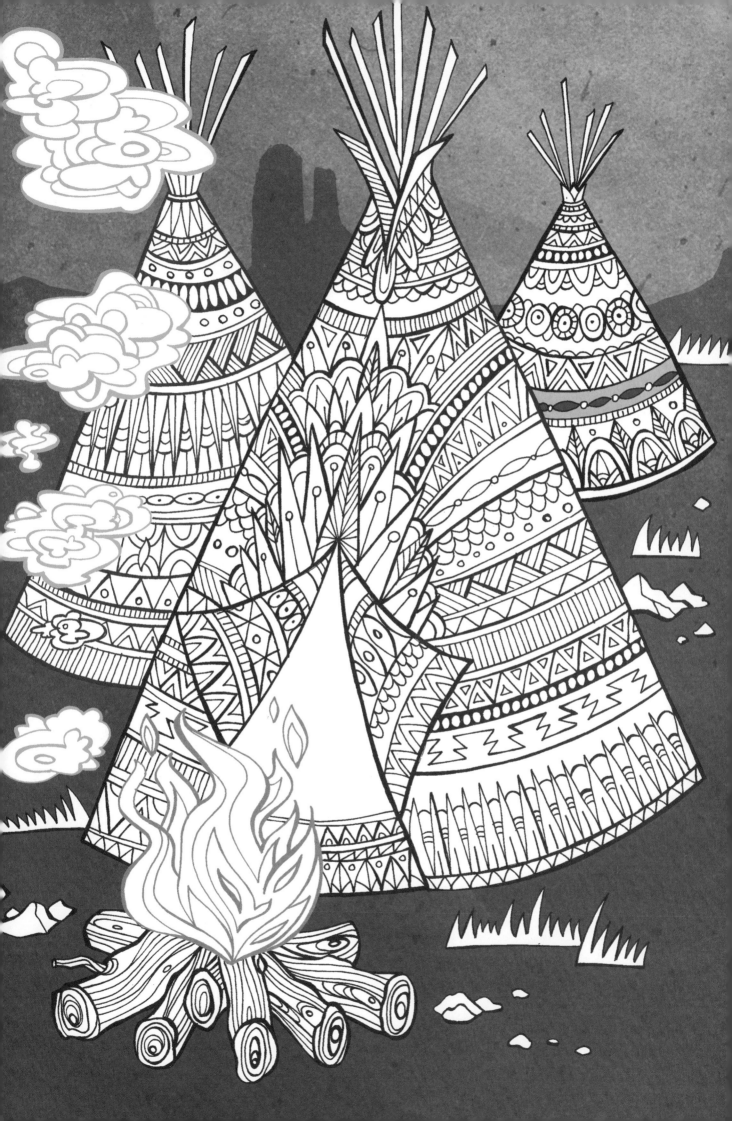

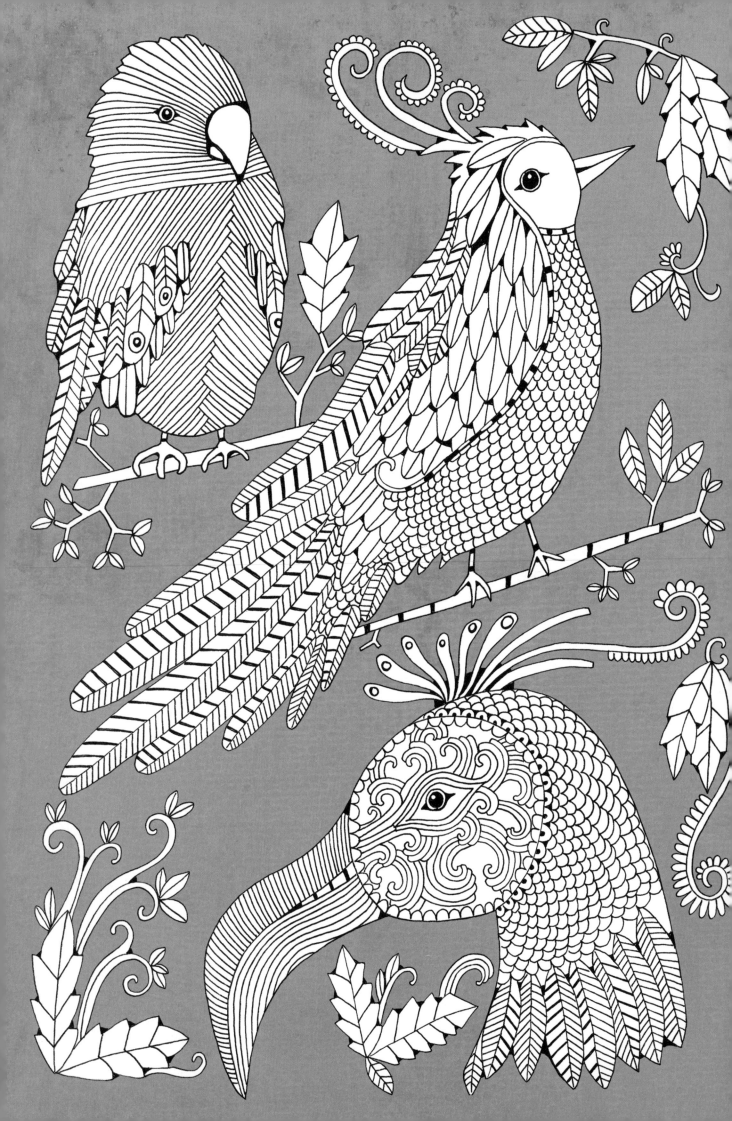

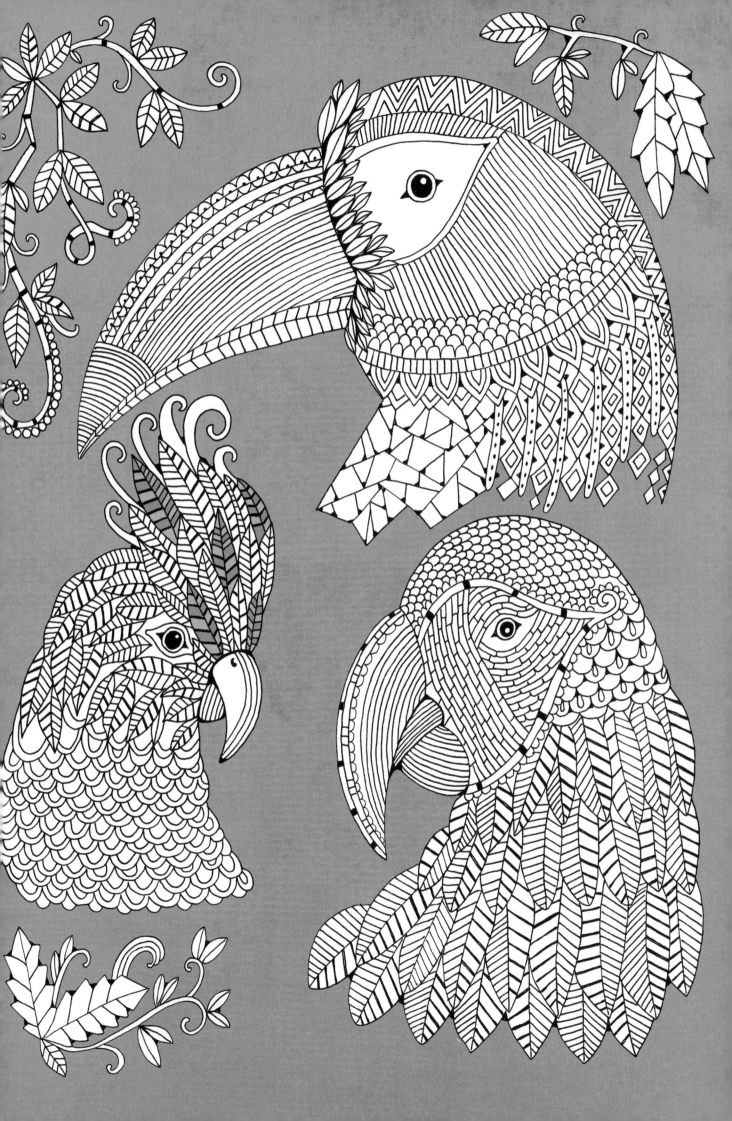

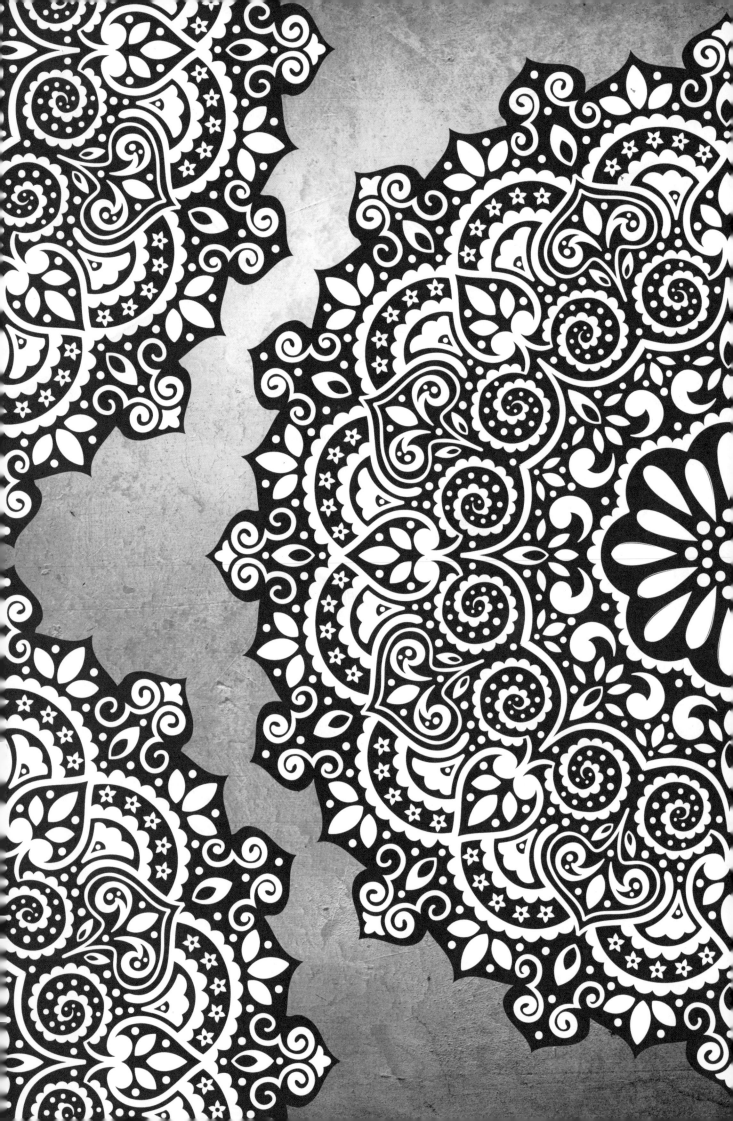

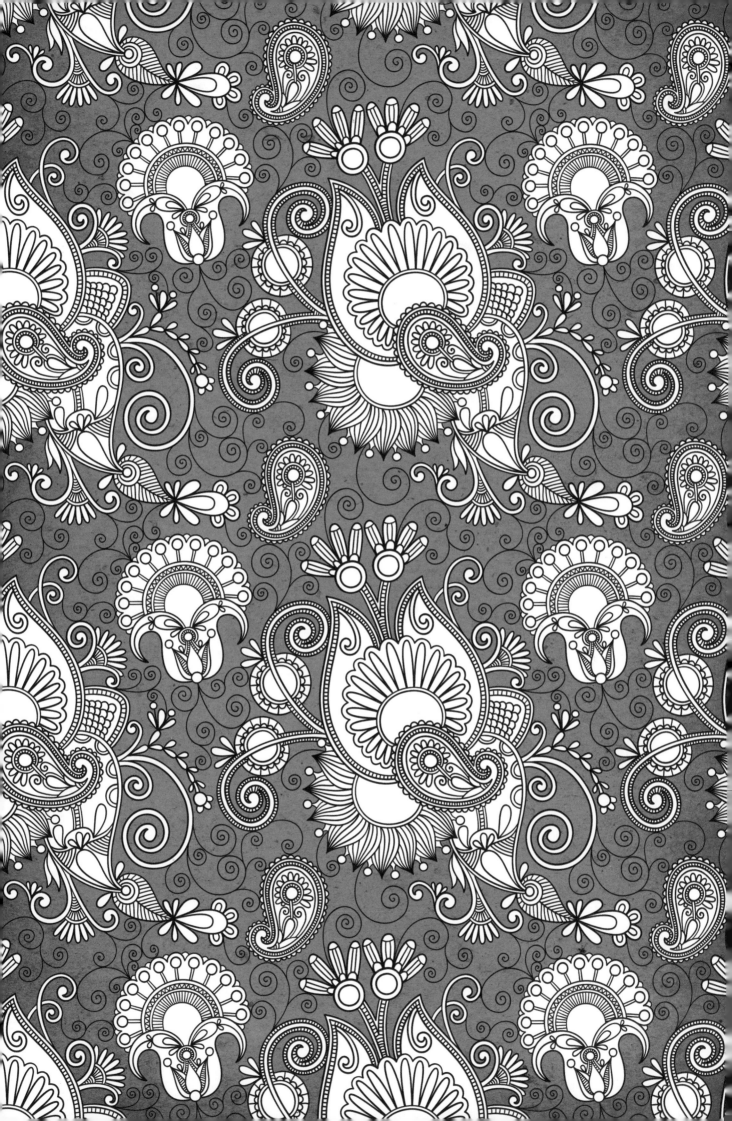

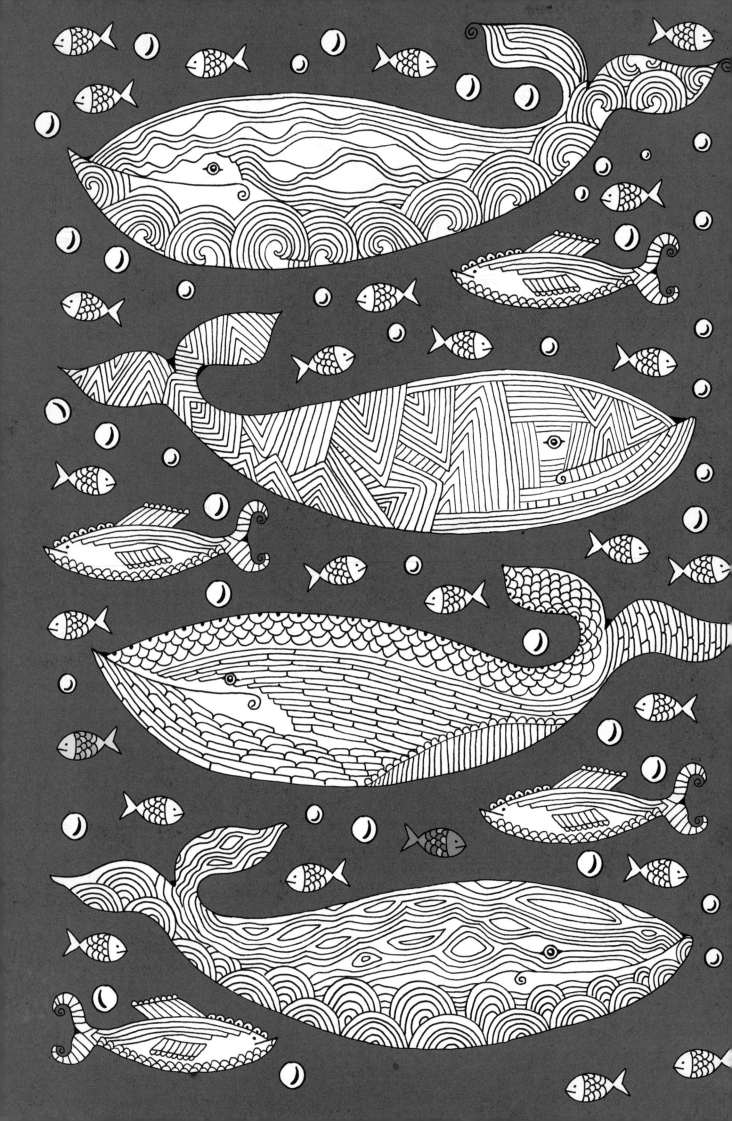

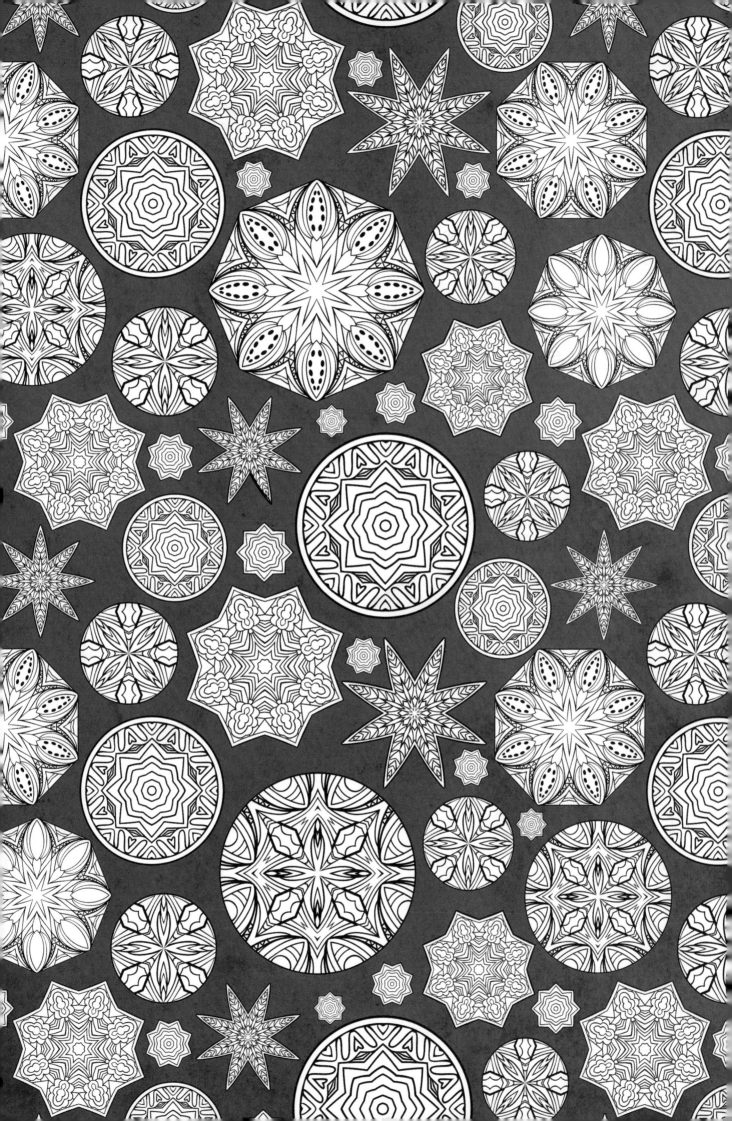

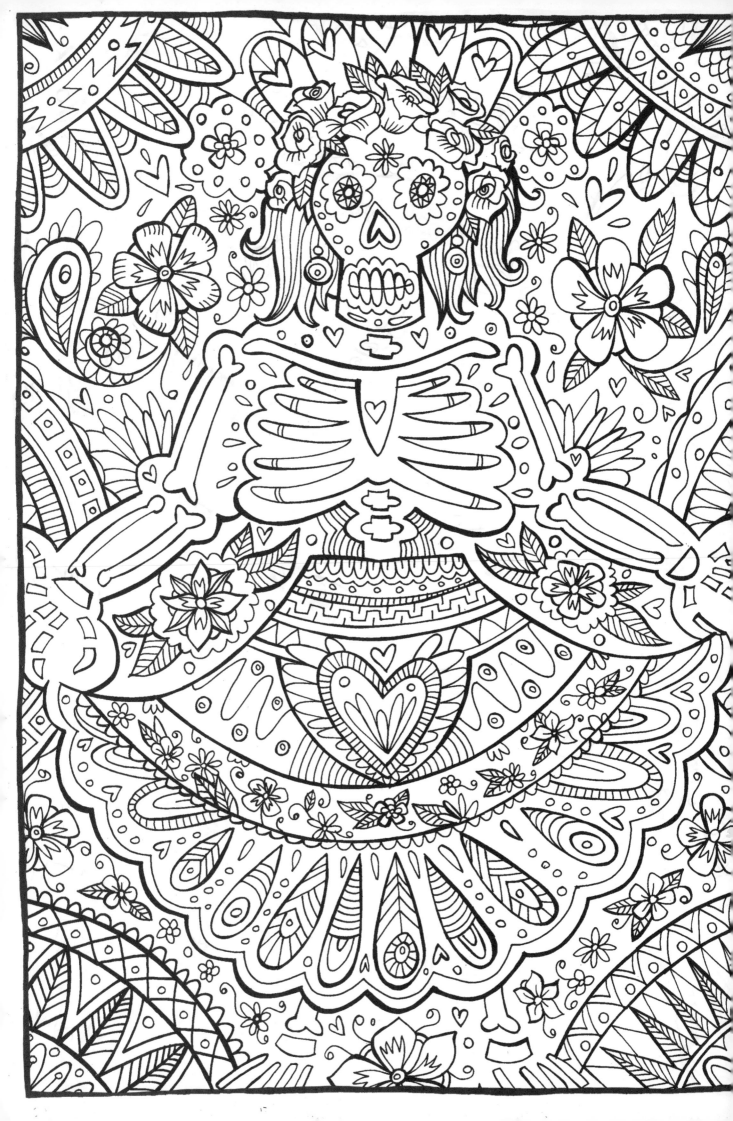

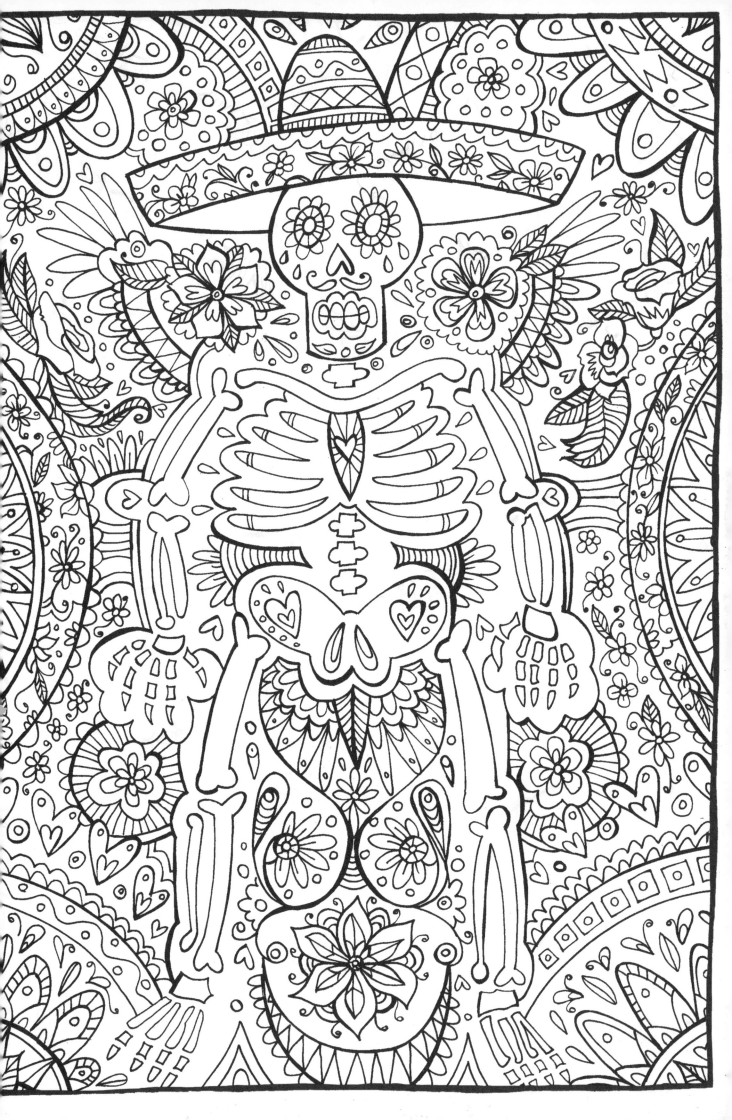

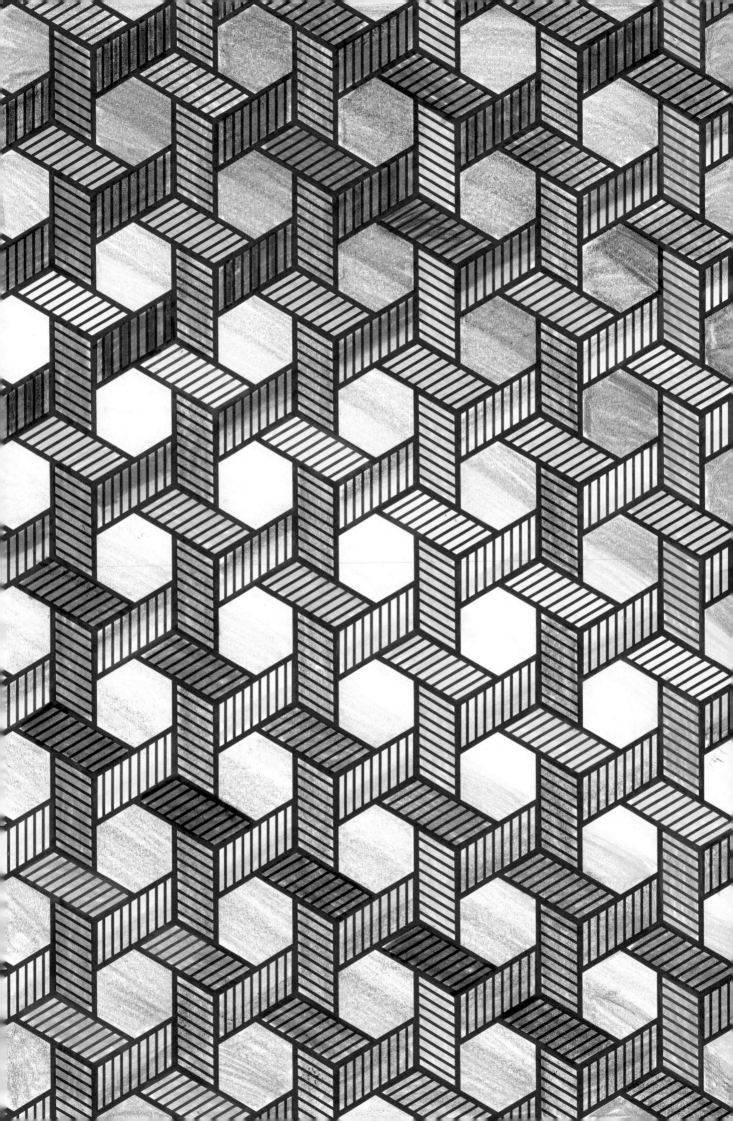

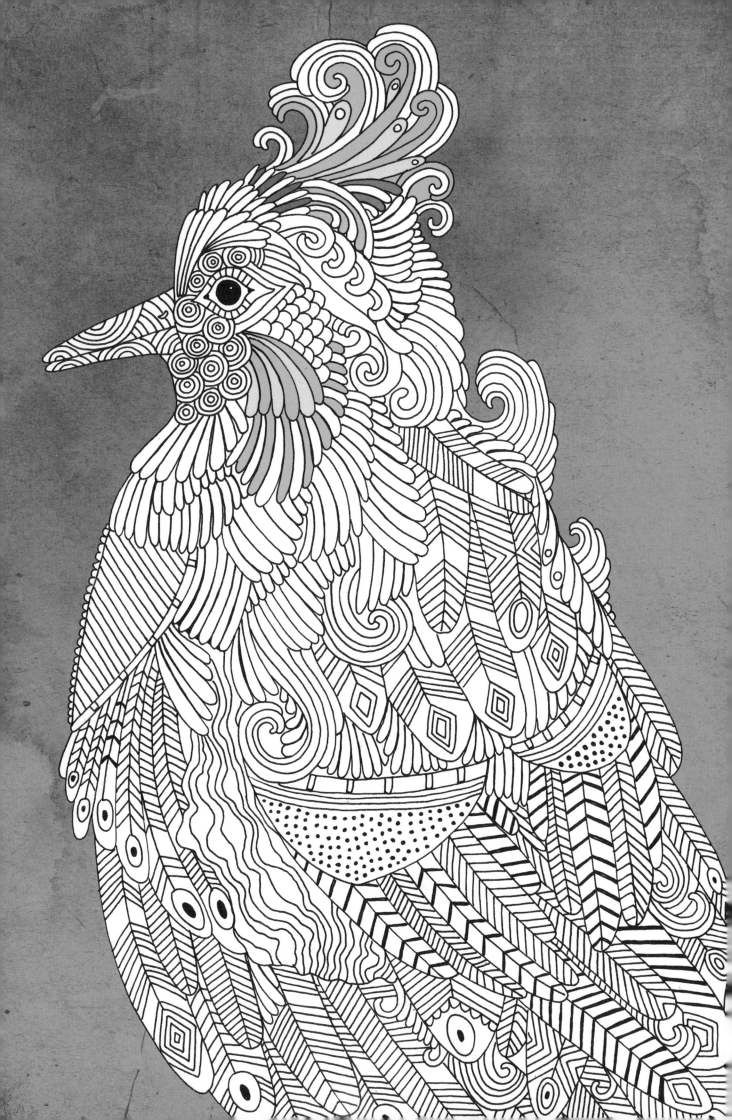

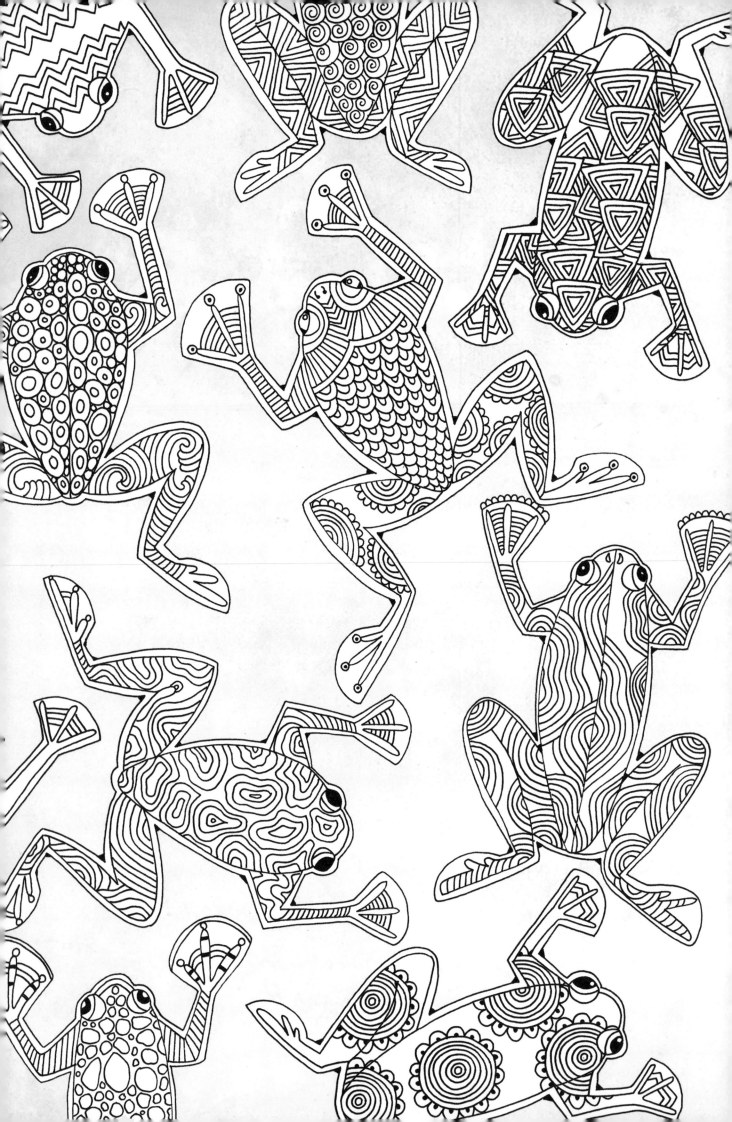

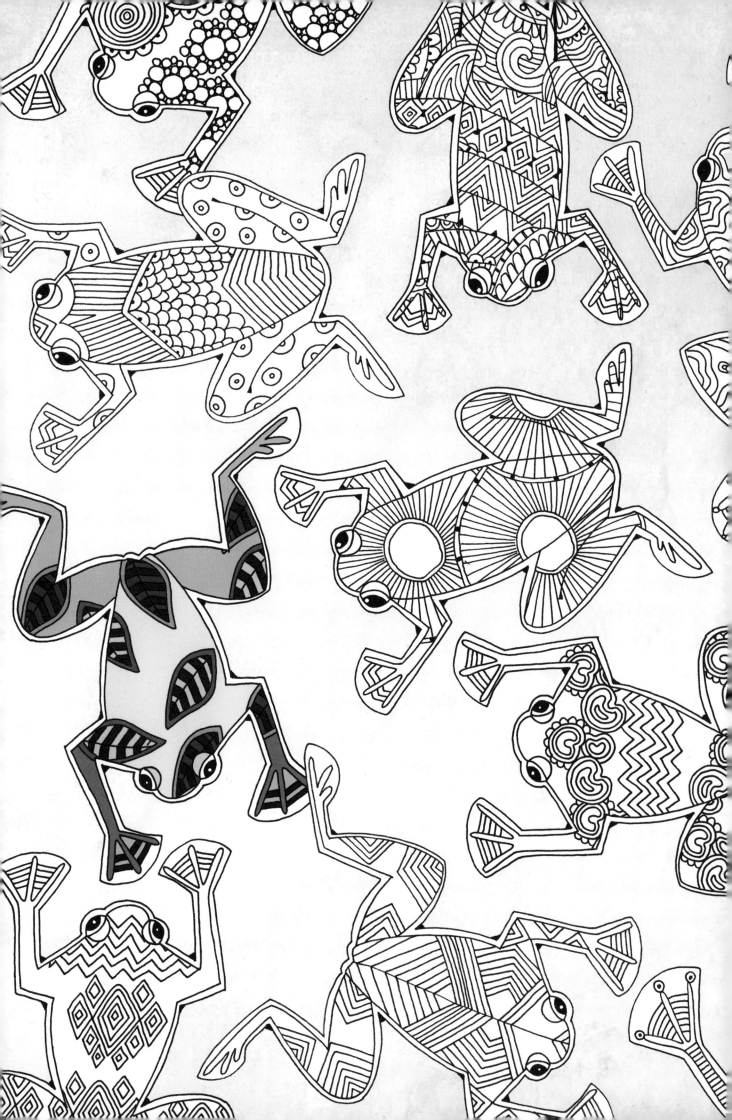

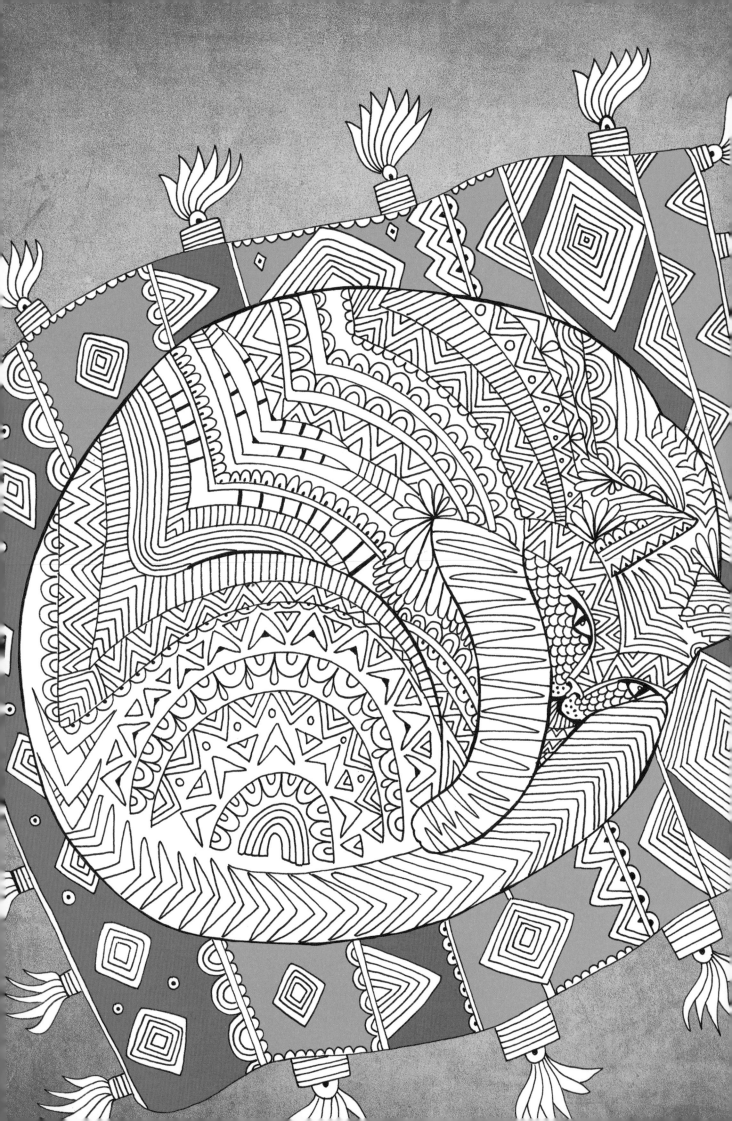

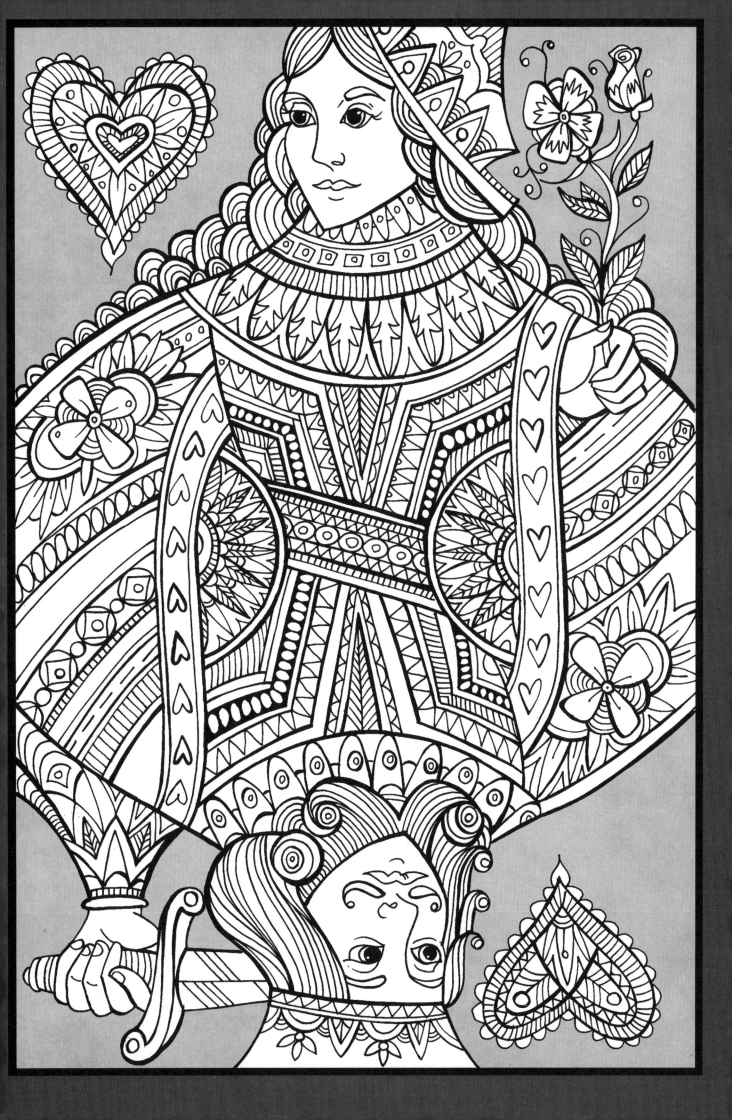

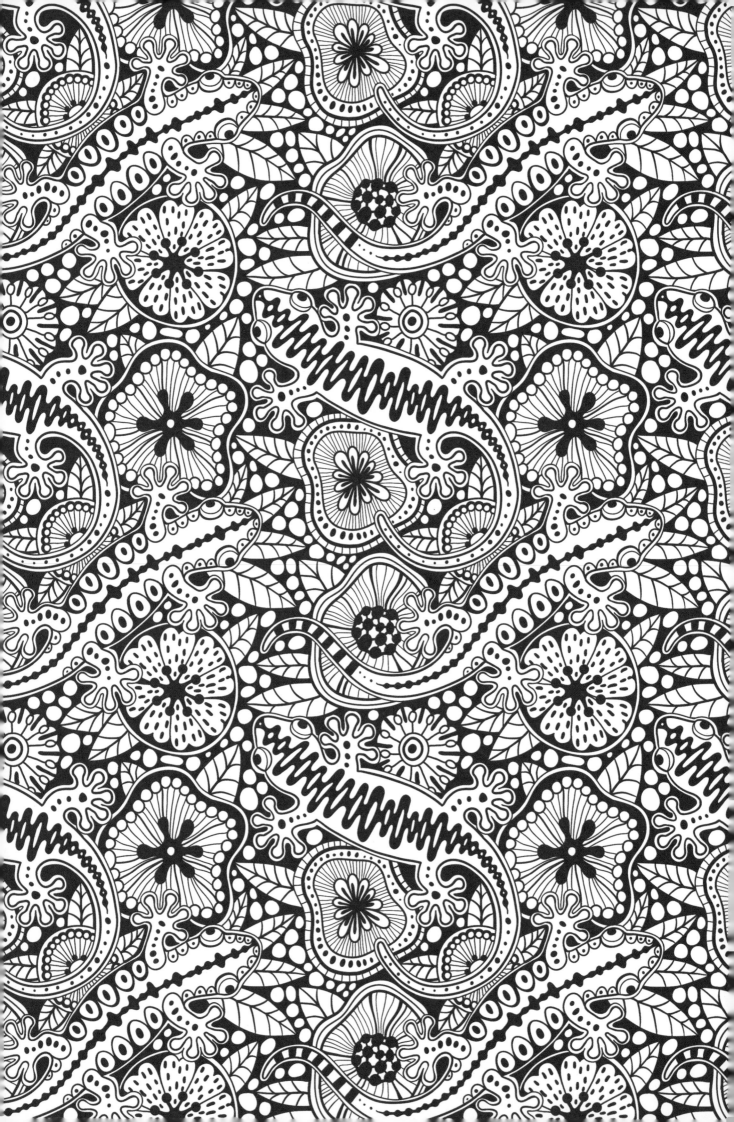

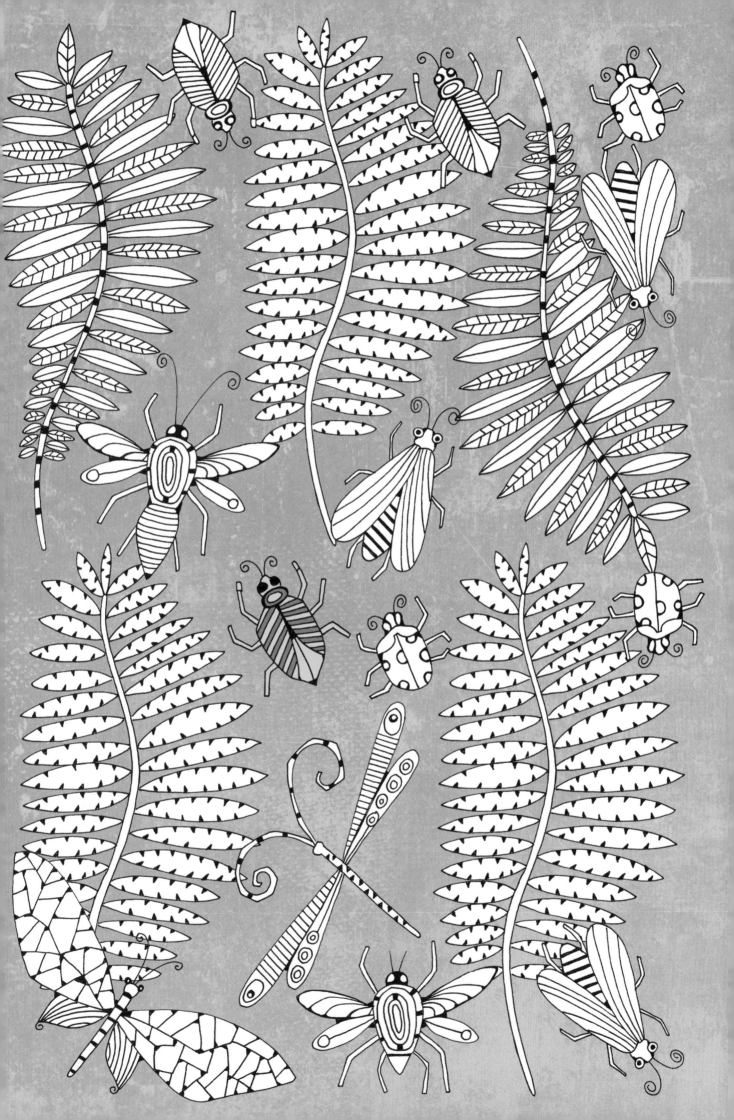

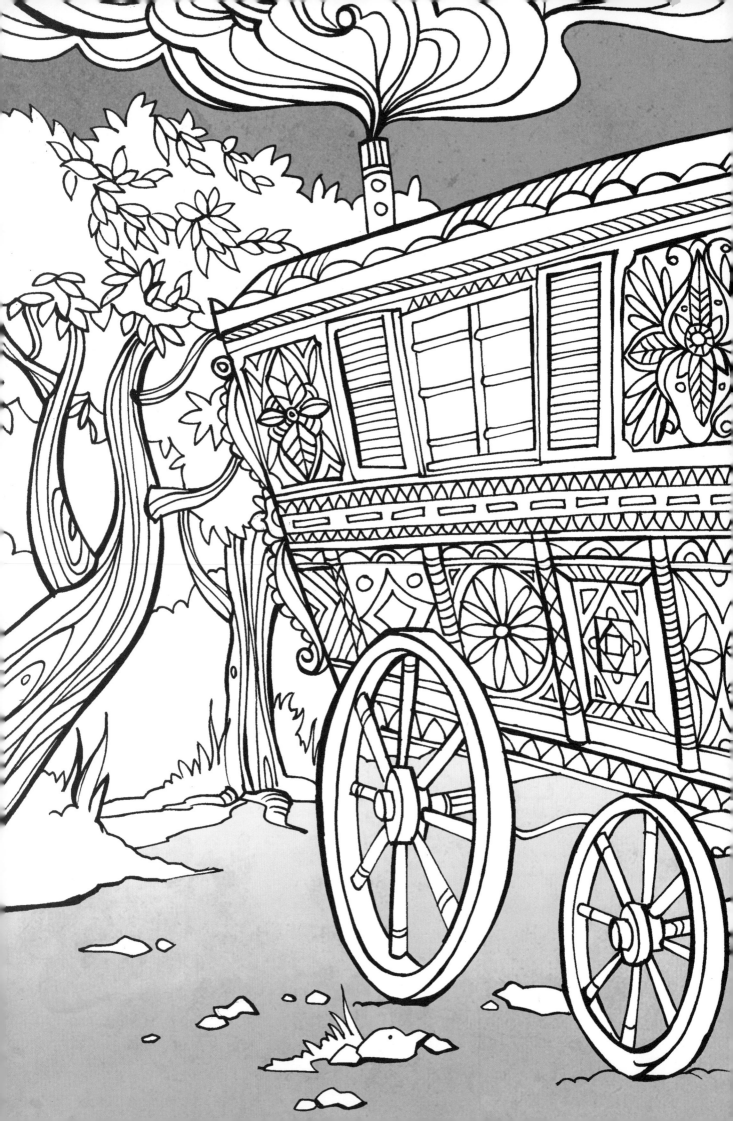

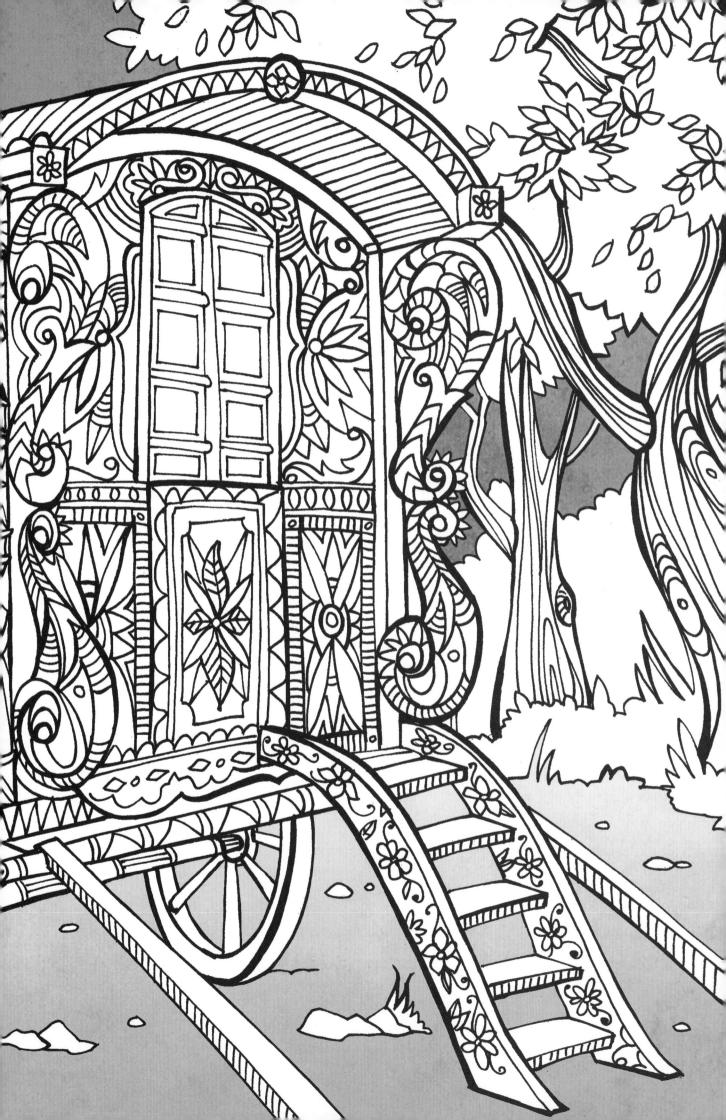

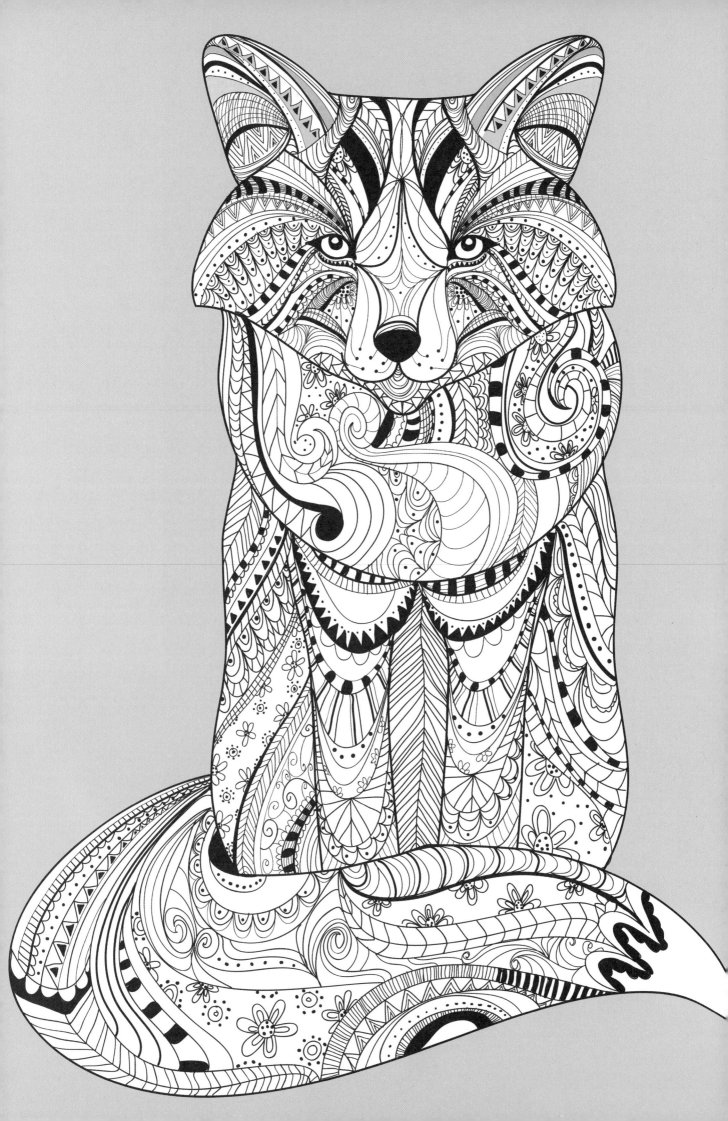

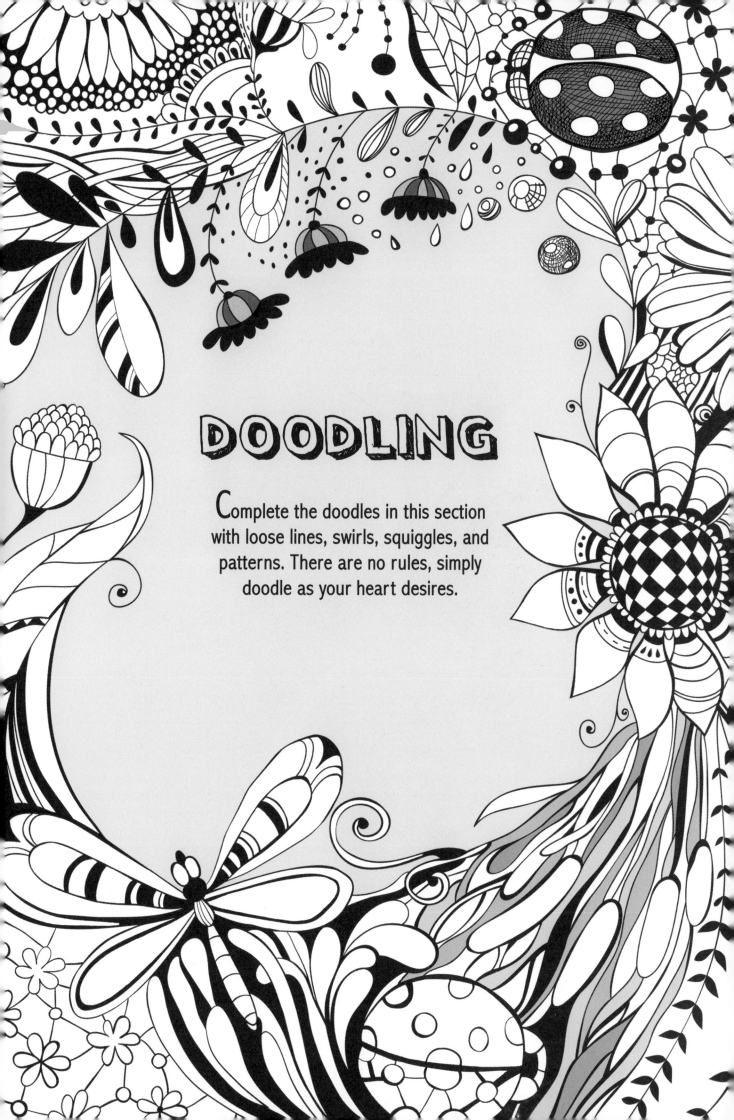

DOODLING

Complete the doodles in this section
with loose lines, swirls, squiggles, and
patterns. There are no rules, simply
doodle as your heart desires.

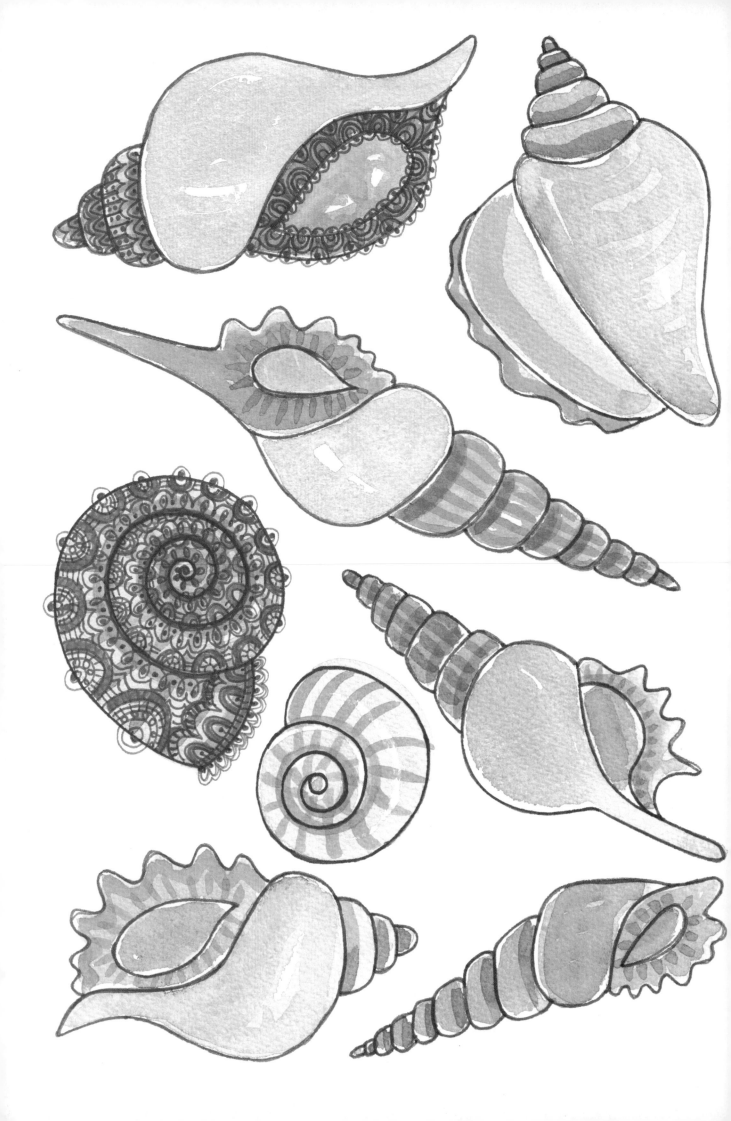

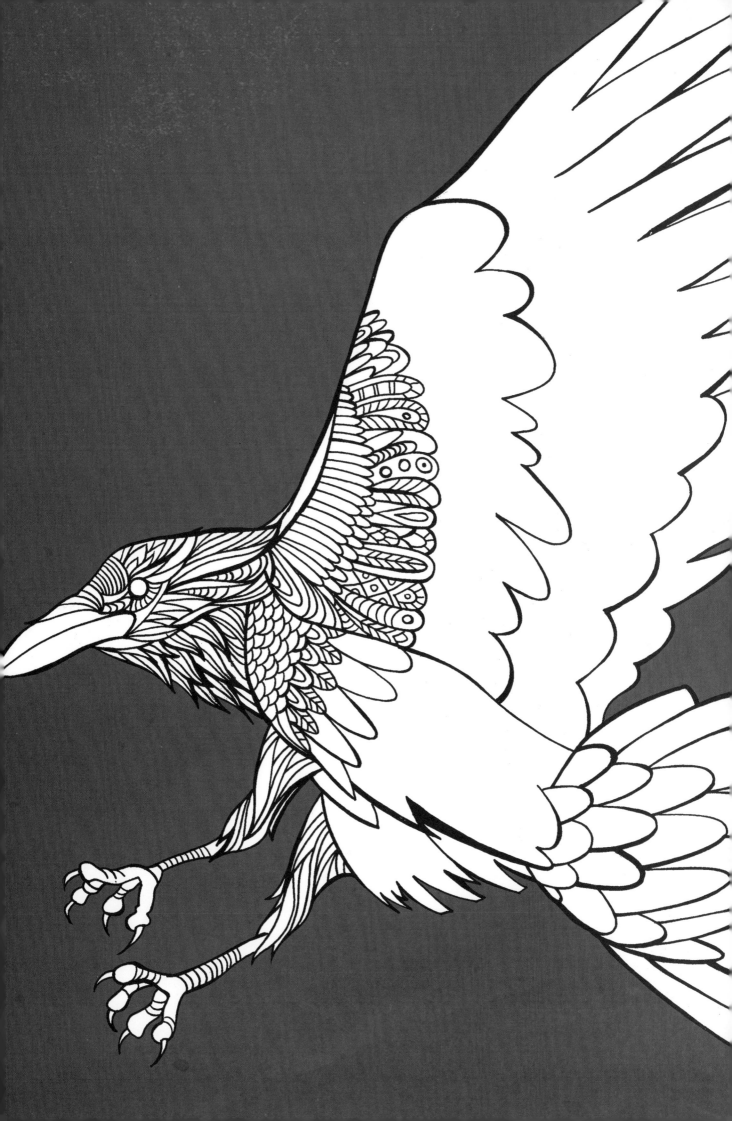

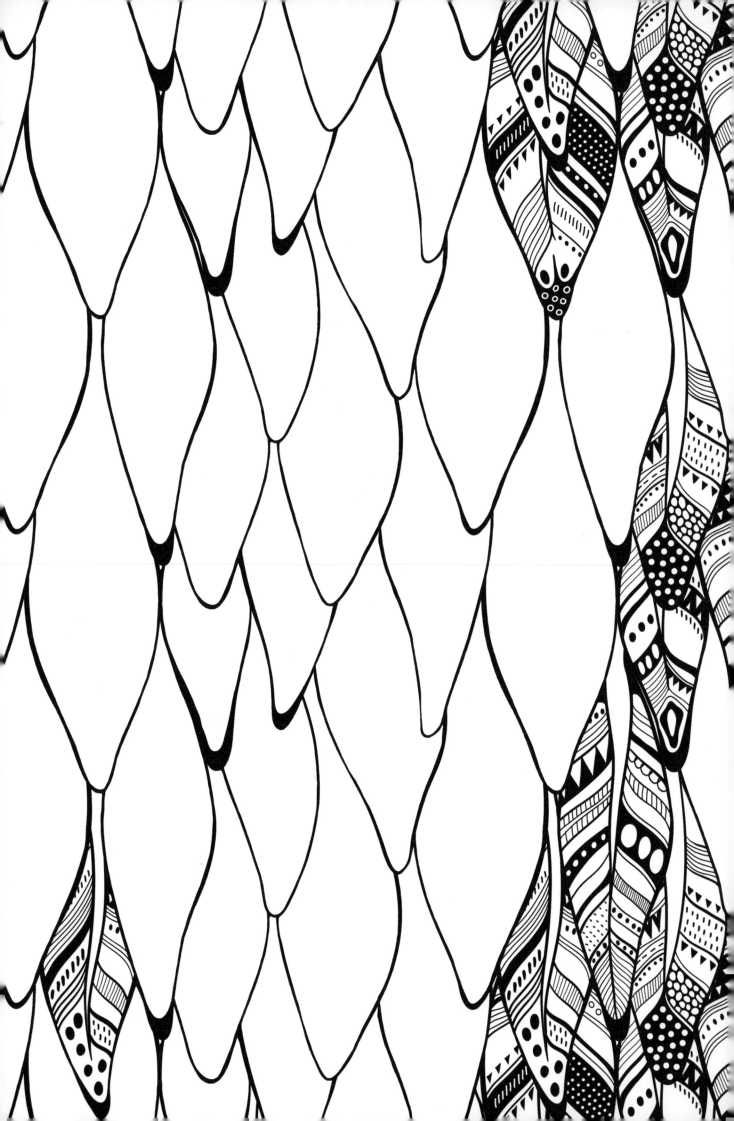

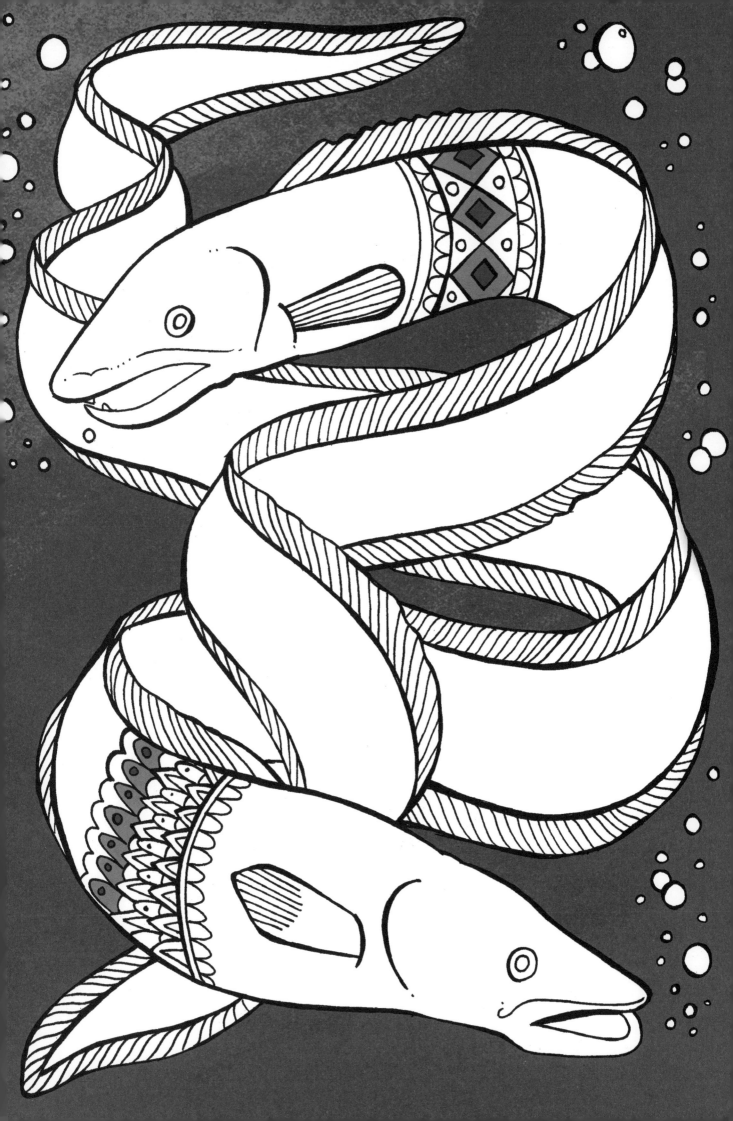

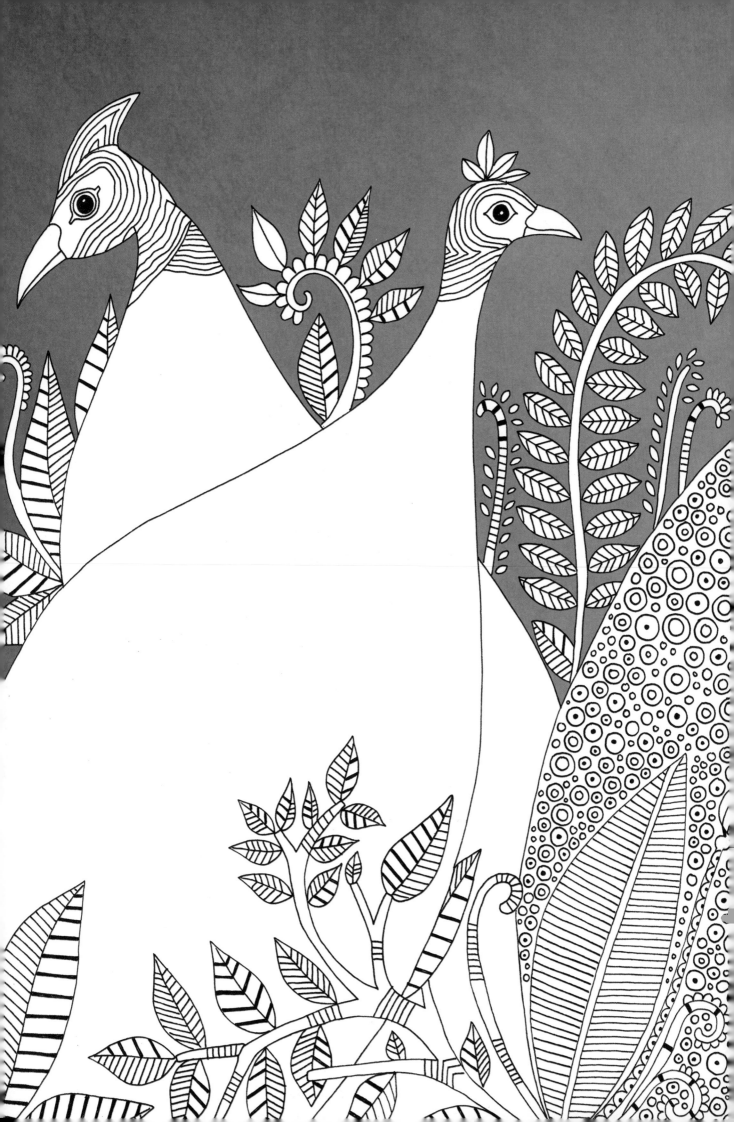

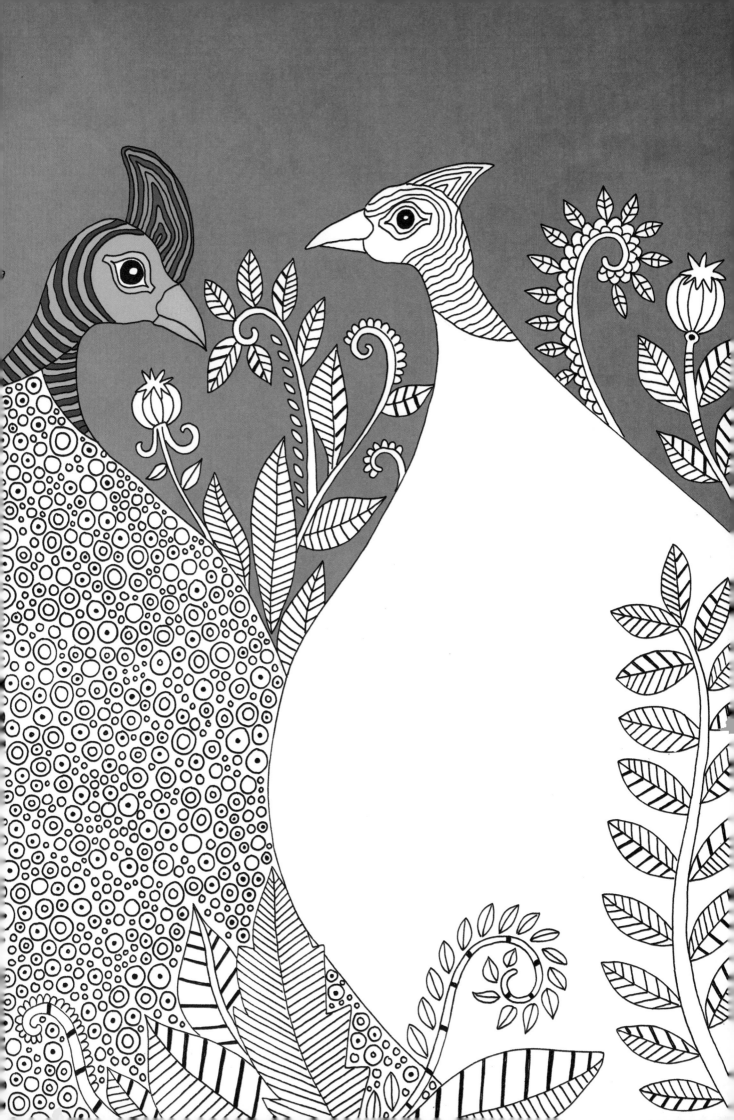

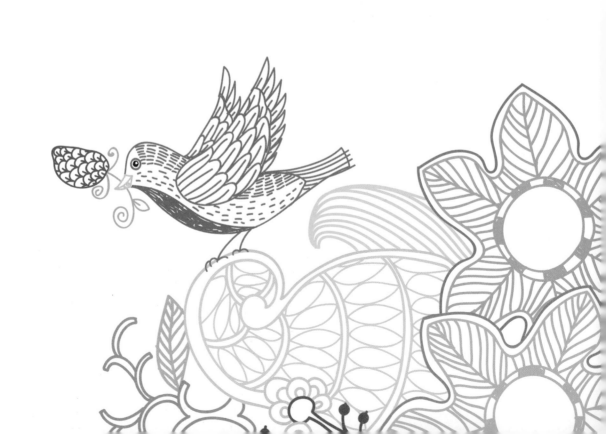

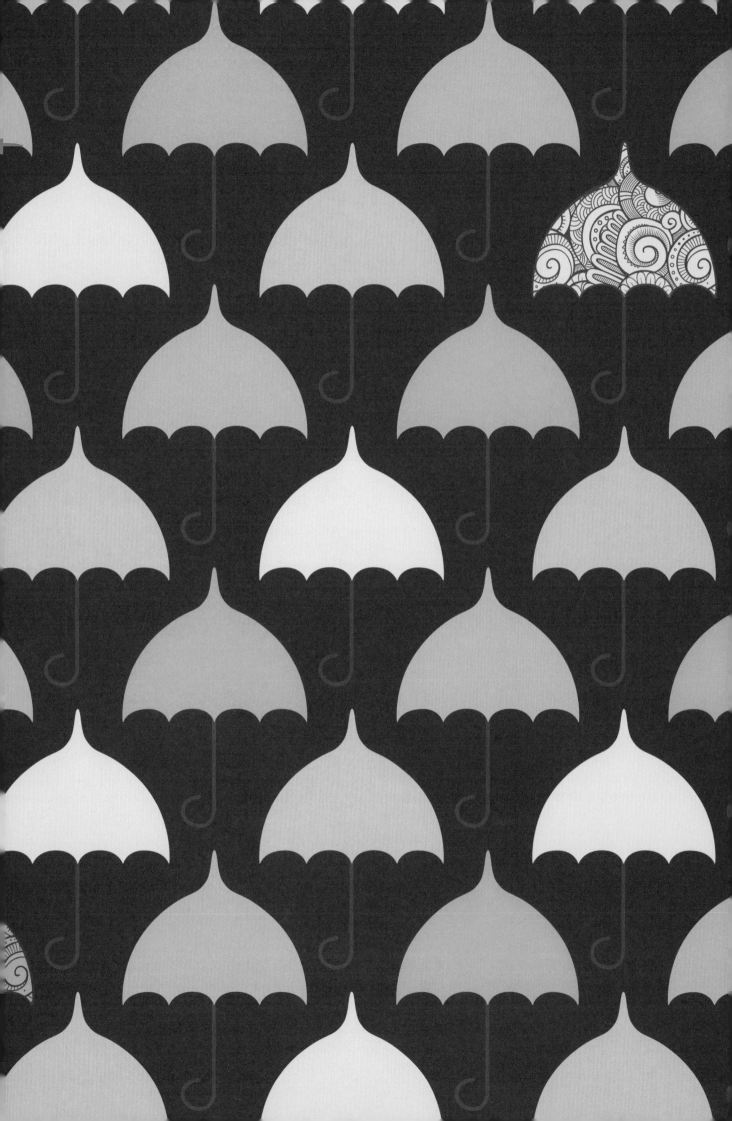

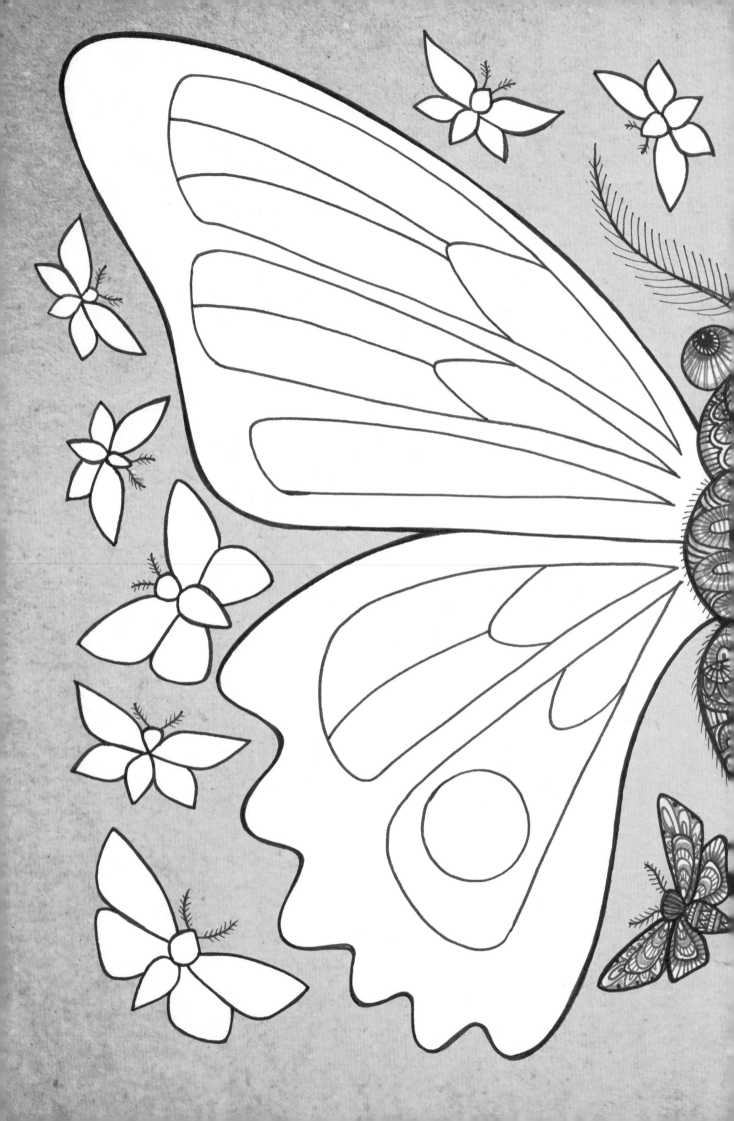

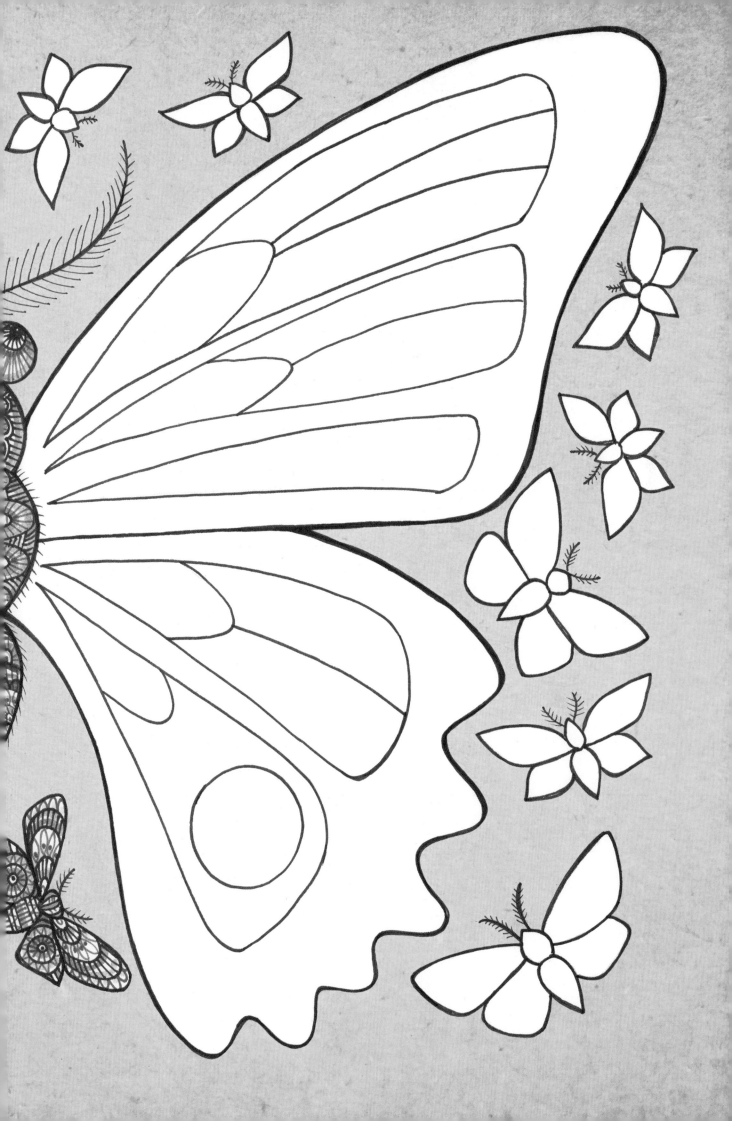

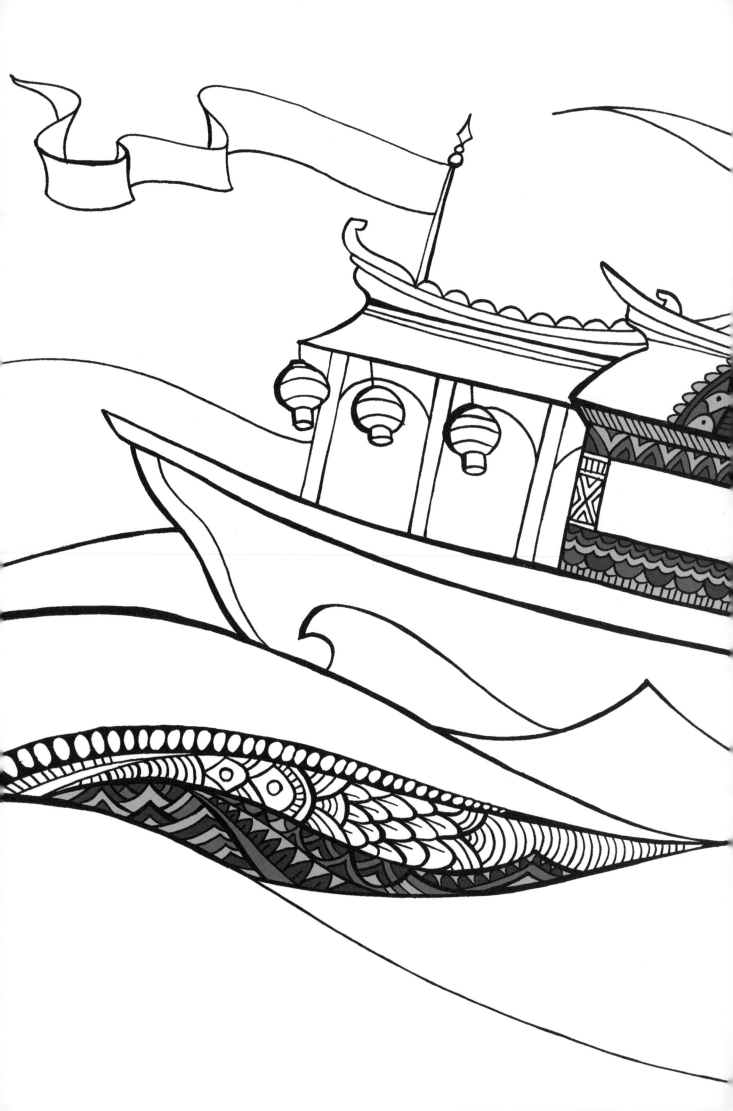

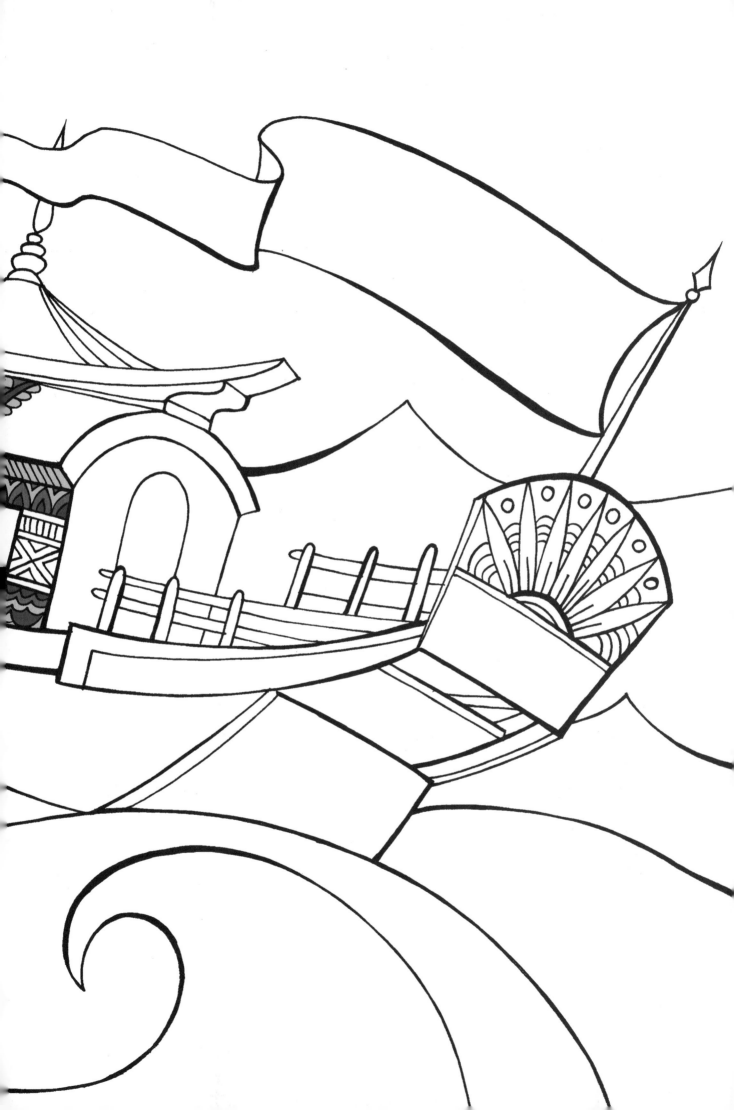

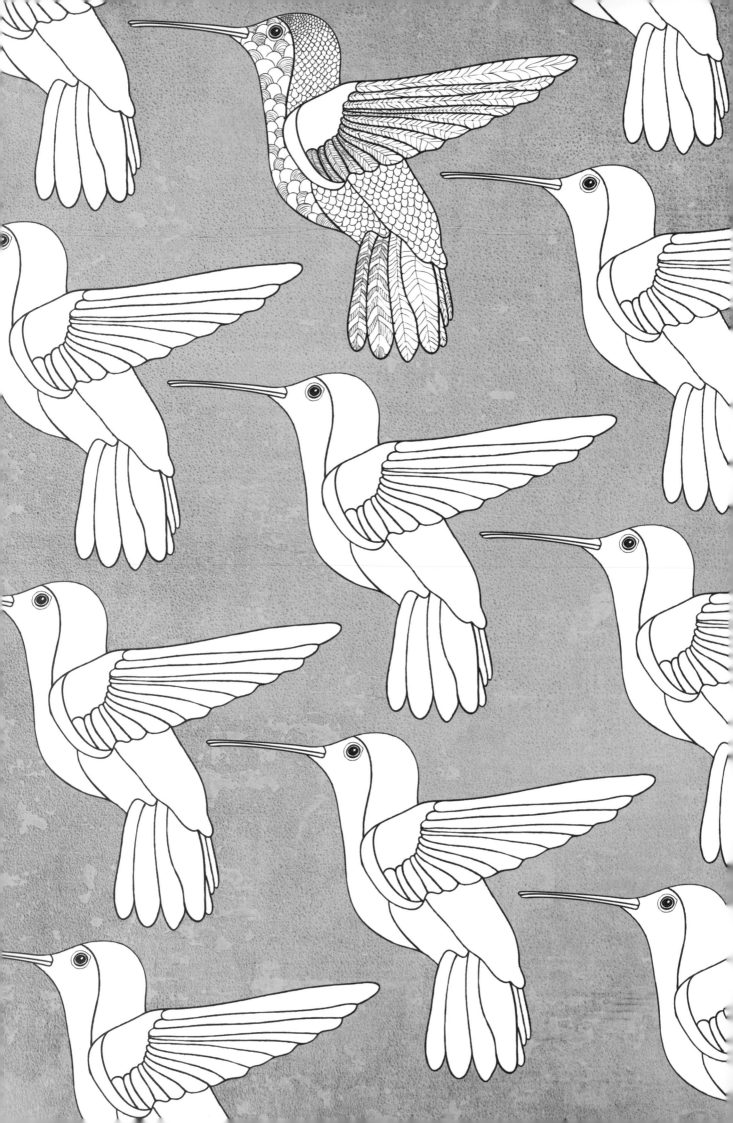

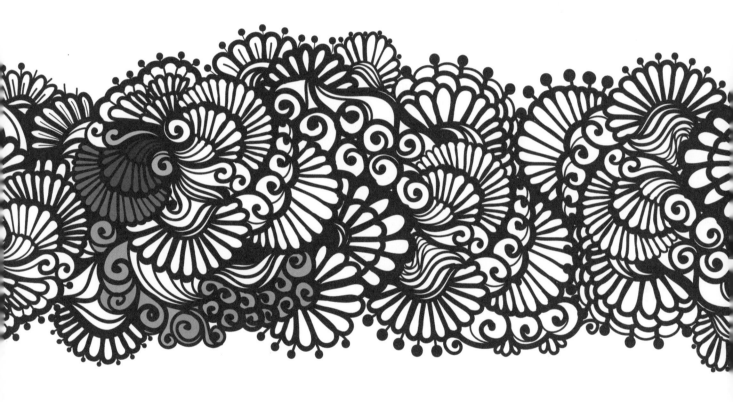

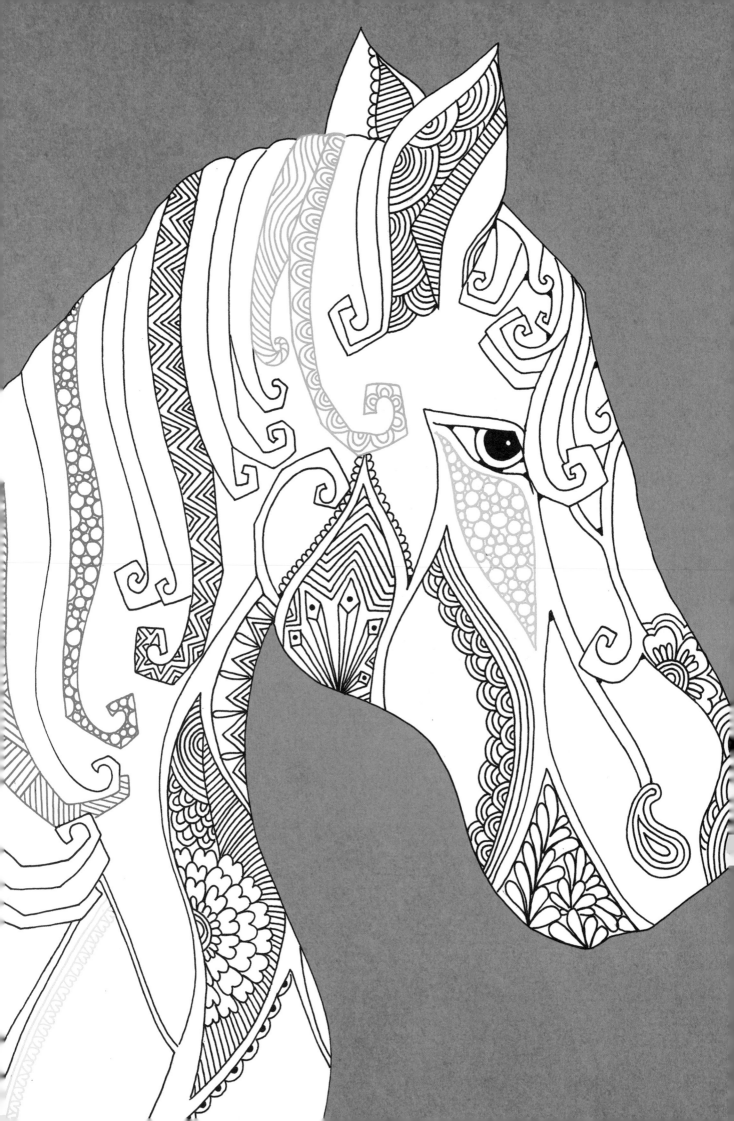

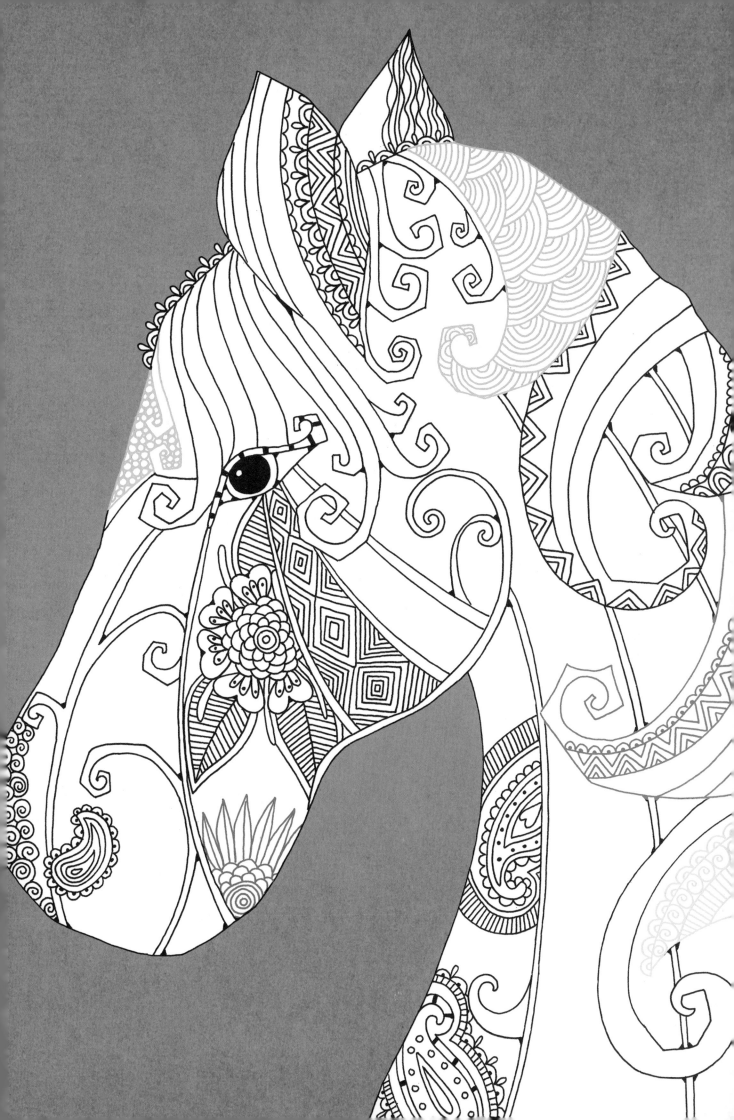

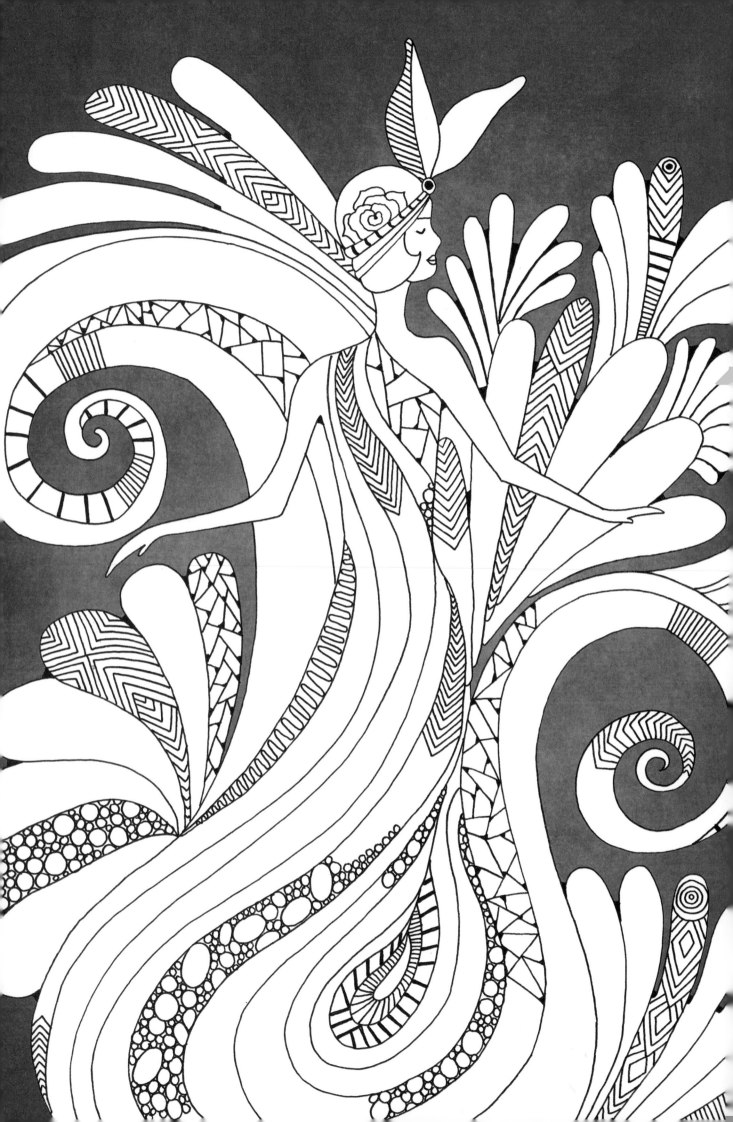

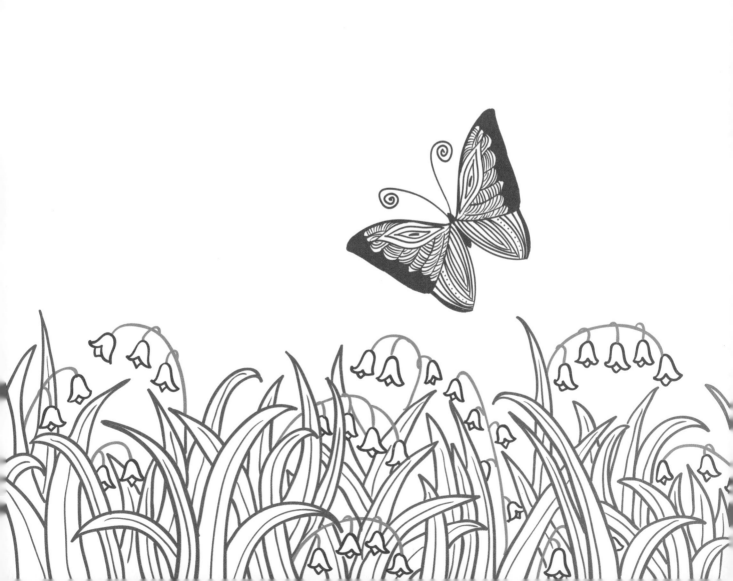

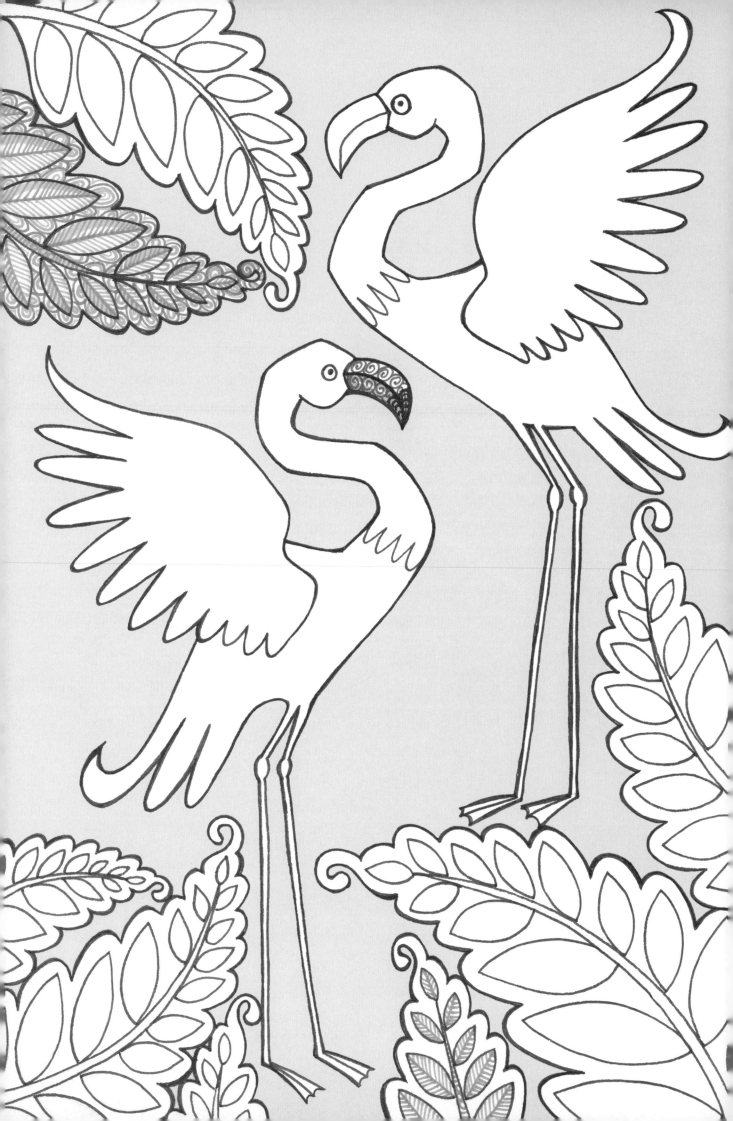

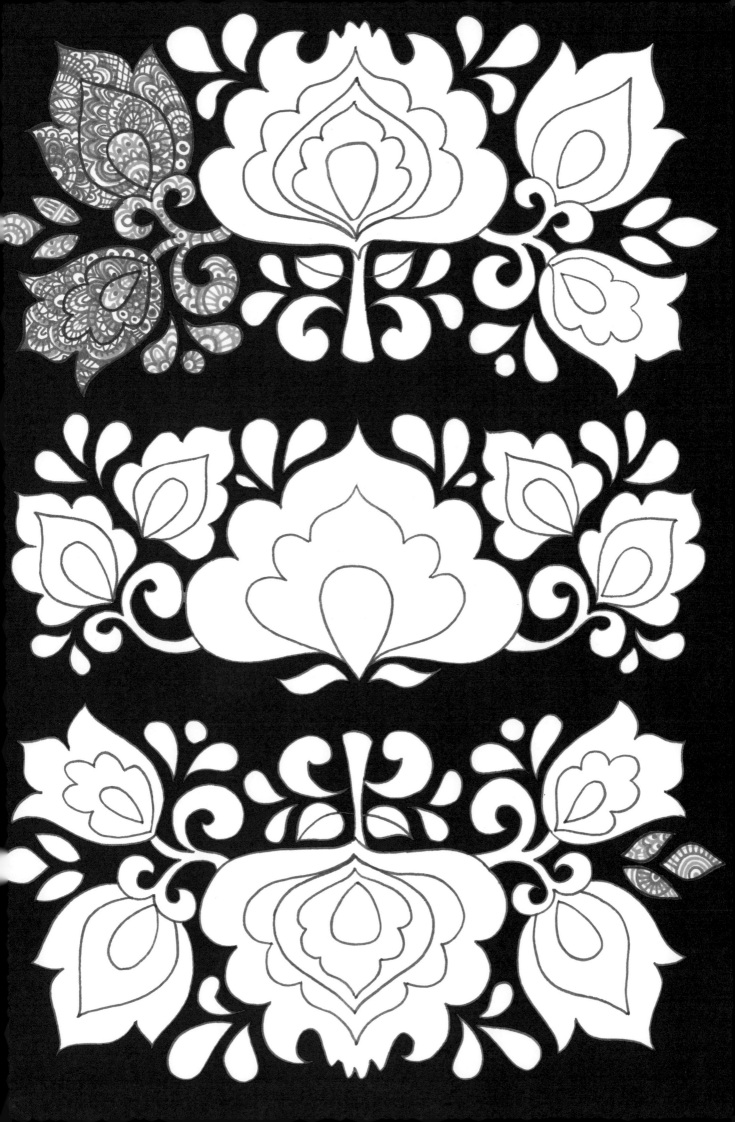

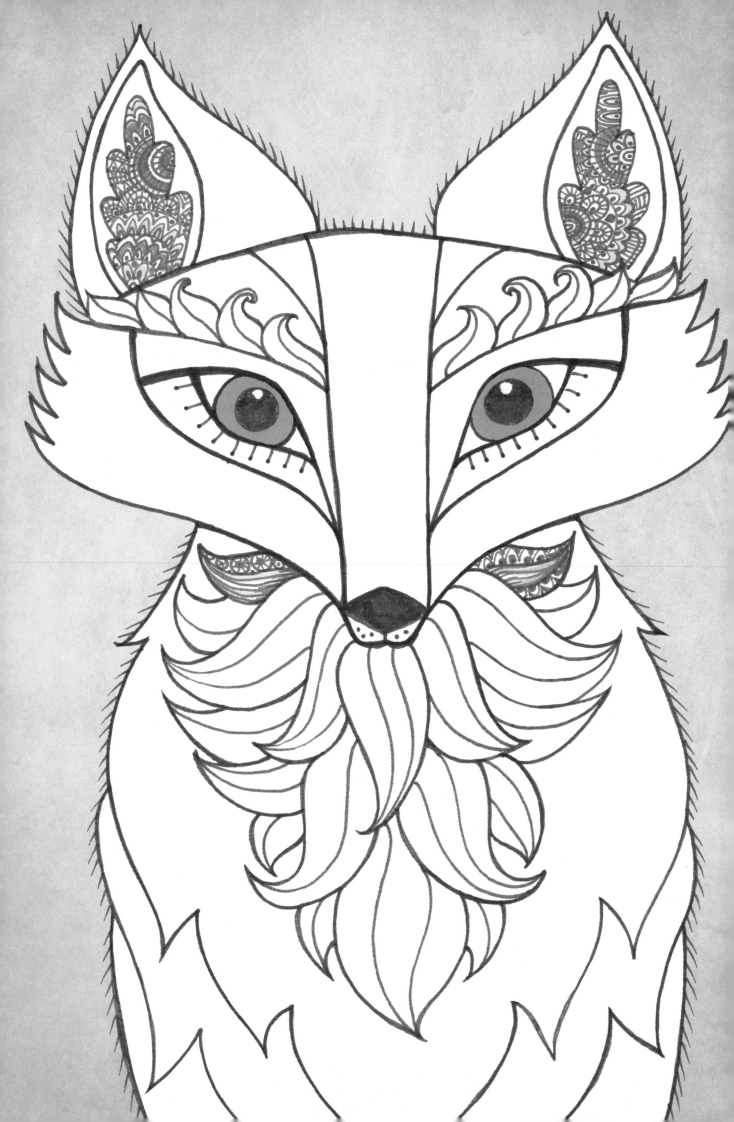

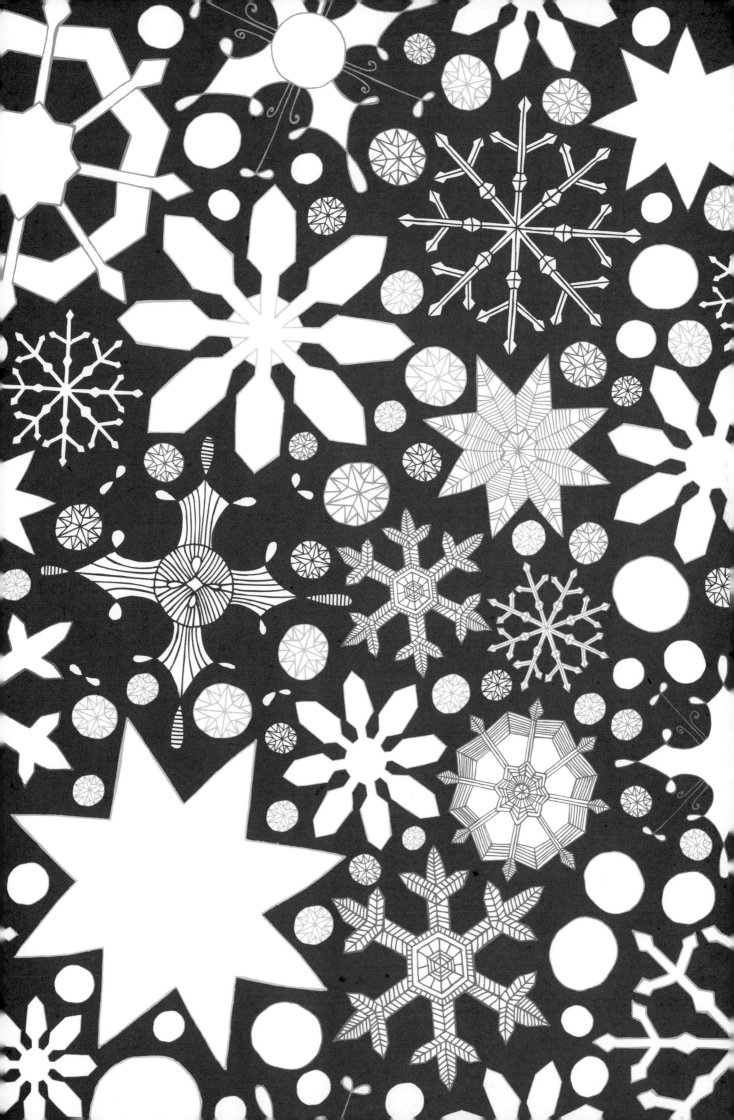

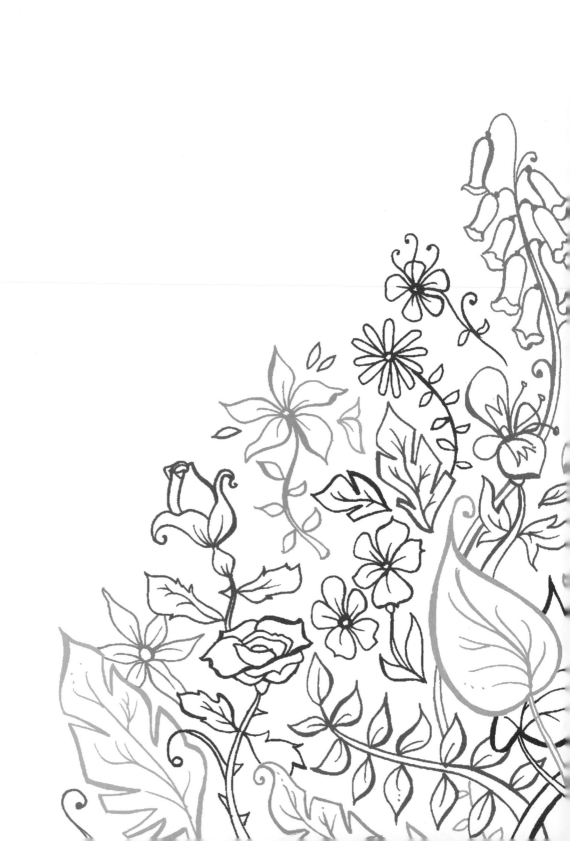

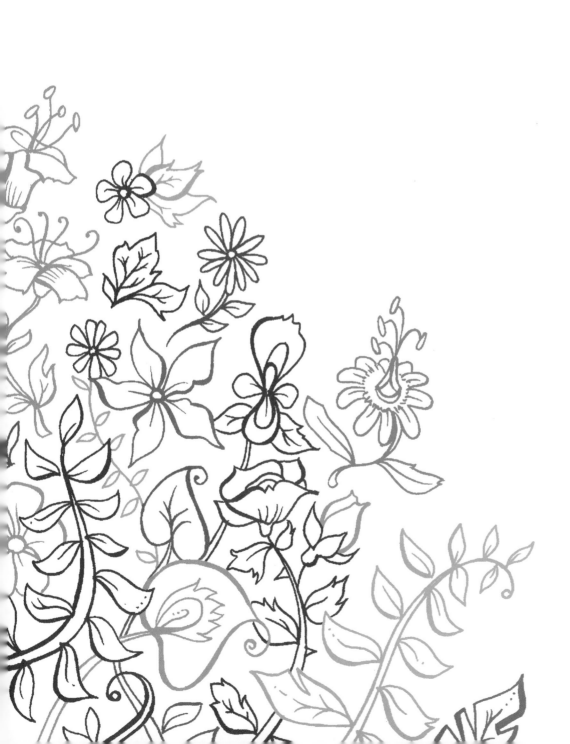

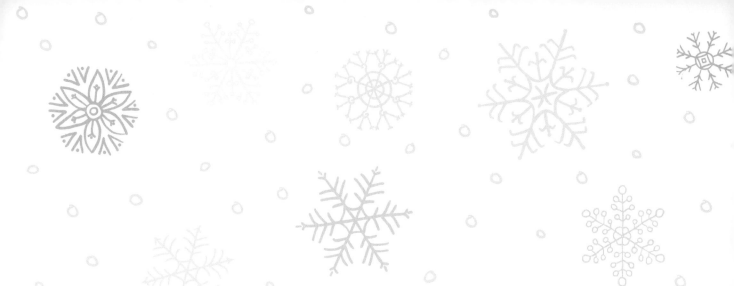

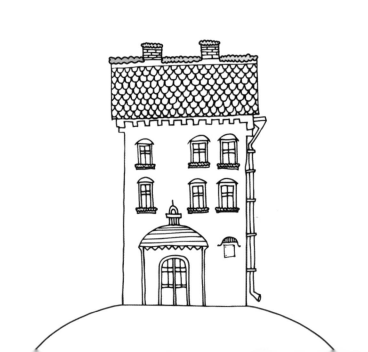

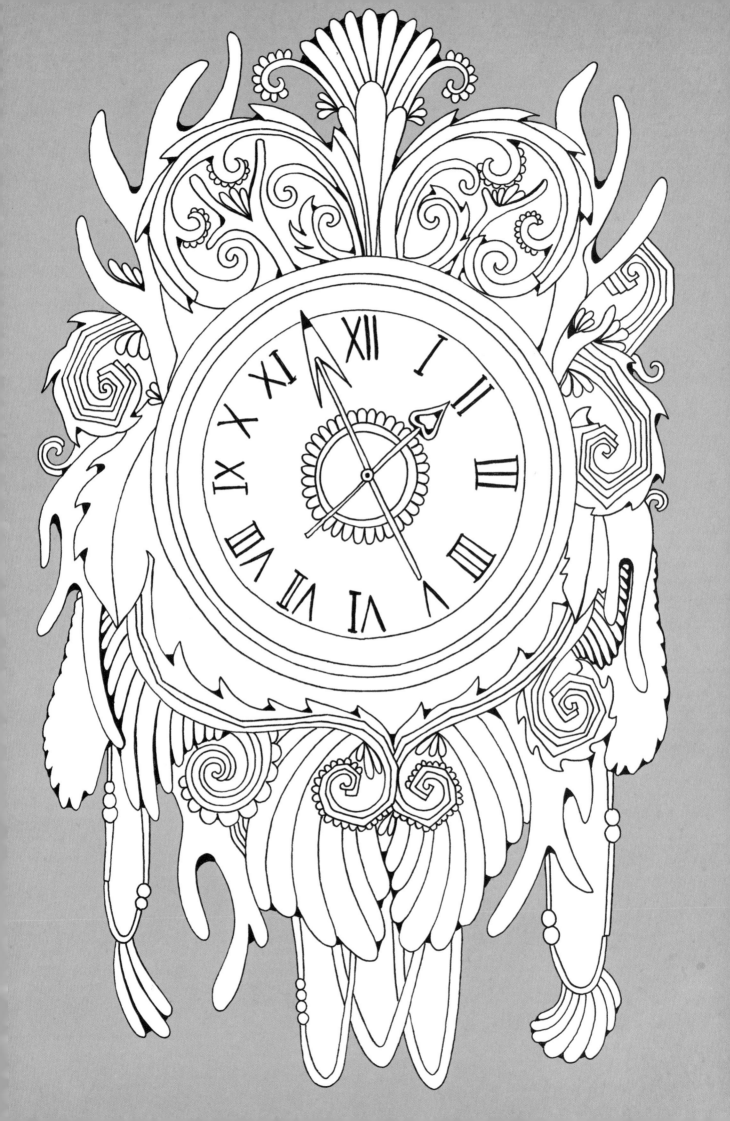

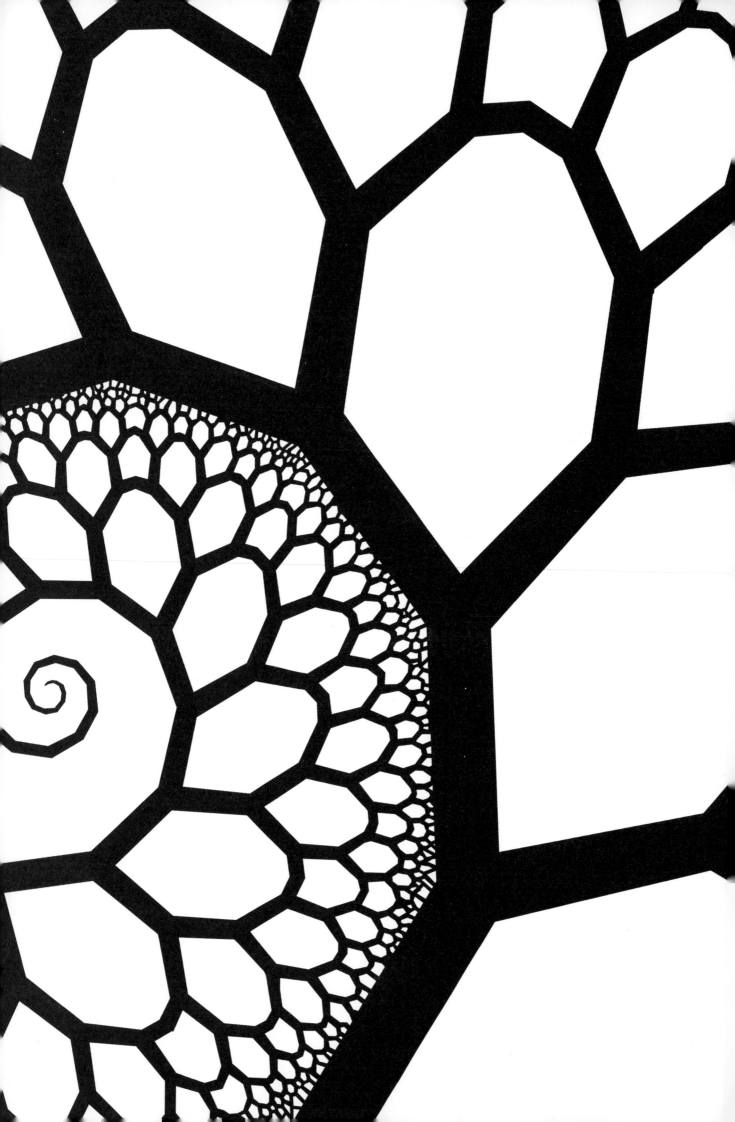

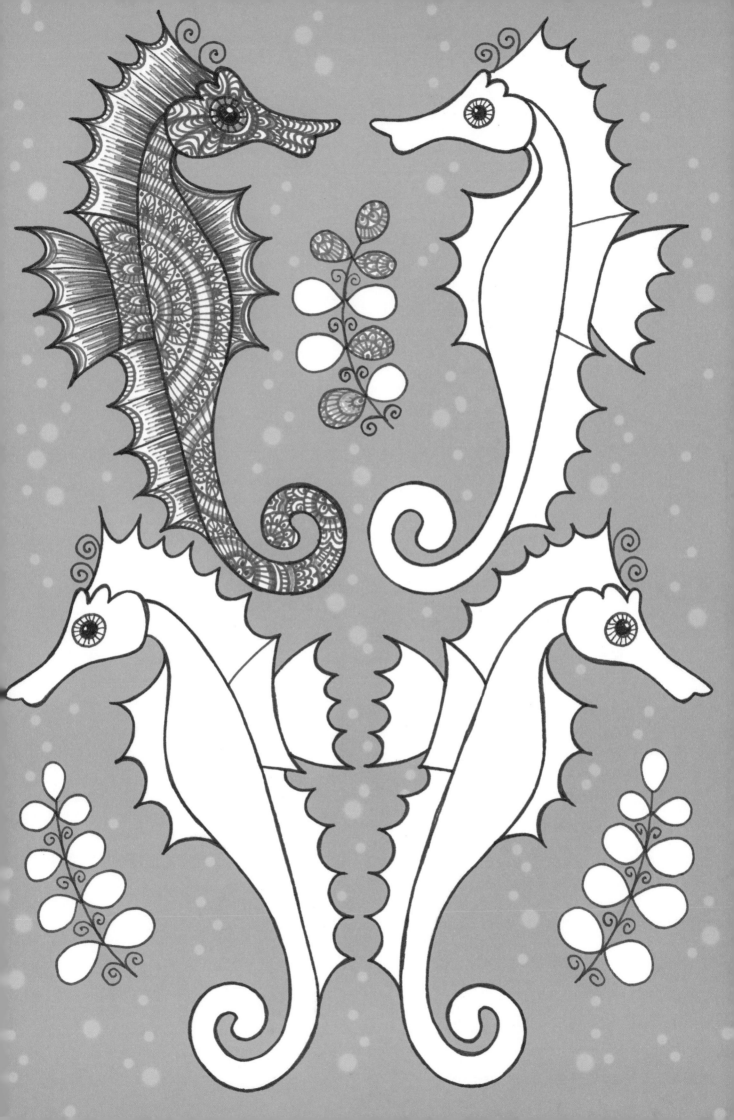

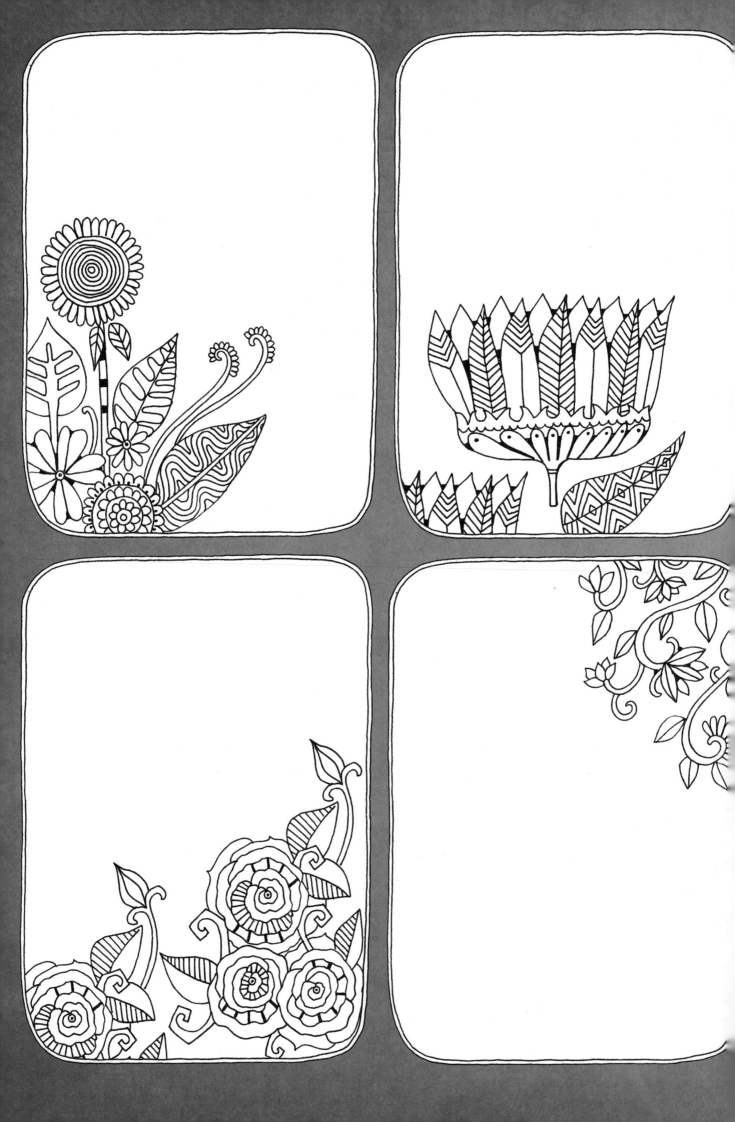

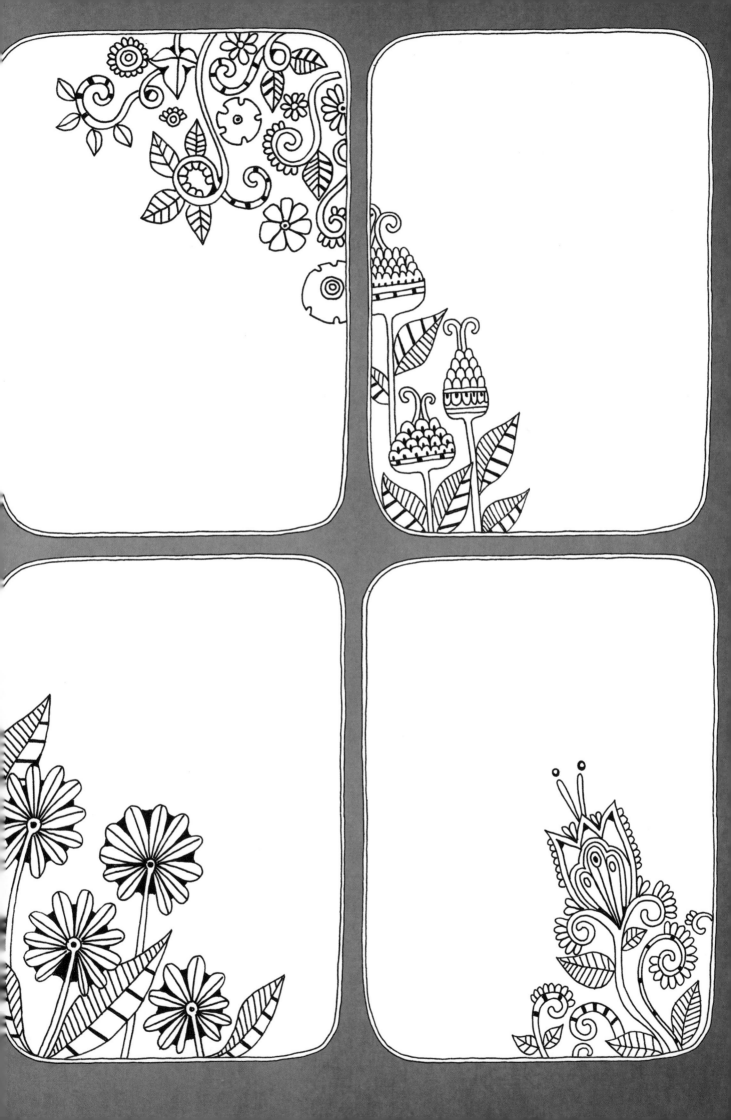